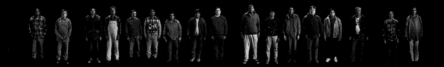

VIEWER

Gary Hill's Projective Installations — NUMBER 3

Text by GEORGE QUASHA AND CHARLES STEIN

STATION HILL ARTS / BARRYTOWN, LTD.

in association with THE BARBARA GLADSTONE GALLERY

Published under the Station Hill Arts imprint of Barrytown, Ltd., Barrytown, New York 12507, in association with the Barbara Gladstone Gallery, 515 West 24th Street, New York, New York 10011. Station Hill Arts is a project of The Institute for Publishing Arts, Inc., a not-for-profit, federally tax exempt, educational organization.

Web: www.stationhill.org; e-mail: Publishers@stationhill.org

Distributed in the United States by Consortium Book Sales & Distribution, Inc., 1045 Westgate Drive, Saint Paul, Minnesota 55114-1065.

Book design and realization by Susan Quasha

Photo Credits: All photos unless otherwise noted, courtesy of Donald Young and Gary Hill; cover and first page photo of *Viewer* courtesy of Donald Young Gallery; the five other photos of *Viewer* and the non-installation detail photos of *Standing Apart* and *Facing Faces* by Lynn Thompson Hamerick; photo of *Tall Ships* by Robert Keziere, used by permission of Ydessa Hendeles.

ISBN 1-886449-50-3

Library of Congress Cataloging-in-Publication Data available

Printed in the United States of America

Contents

Preface

Viewer is the third volume in our series on Gary Hill's projective installations, following upon *HanD HearD/liminal objects* and *Tall Ships*. This volume focuses on three installations—*Viewer*, *standing* apart and *facing faces*— first exhibited at the Barbara Gladstone Gallery in November of 1996. Earlier, substantially different versions of the four texts presented here have appeared in catalogues for exhibitions in New York, Vienna and Rio de Janeiro. The four texts were written with the intention of being reworked and woven together in a single fabric. This book, which is the product of that interweaving, still bears the stamp of the occasions of composition. (These texts are, so to speak, in dialogue with their occasions, as well as each other and the other two books in the series.) We hope that the shifts in surface texture, pace and strategic orientation in the four pieces contribute to, rather than detract from, our main purpose: To open a particular access to these new works in such a way that we enhance participation in their further life.

This notion of *further life* has come to represent our aspirations not only for our own writing with respect to another artist's work, but for the appropriate participatory relationship of viewers generally to work of such complex possibility. We hold with those who consider the viewer/reader to be co-creative with the work of art, and we think that an artist such as Gary Hill, who works with what we call *open intentionality*, works *into* the possibility of co-creativity. The viewer plays an essential role in the further life of the artist's work, and the artist who *deeply* knows this orients his work toward open and individuated viewing. The viewer is the necessary fertile force that furthers the life of the work. Hence the title of Gary Hill's projective installation, signifying his own exploration into the nature of *viewer, viewing space* and *view;* hence, too, our choice of the same title for the present inquiry into the series of recent projective works.

Respect for the viewer means openness to the *other*—another key concern that runs like a subtext through the three installations (as it did through *Tall Ships* before them). It involves the problematics of the presence of the other, the otherness of presence, the otherness of subjectivity, and the subjectivity of otherness—knotty dualities that Gary Hill's various practices and techniques of video projection are deployed to *disturb* and perhaps overcome, without oversimplifying. The varieties of otherness (by definition, potentially unlimited) show up differently in *Tall Ships* and these more recent pieces. In *Tall Ships* the projected figures were drawn mainly from the artist's everyday acquaintances—family, friends, friends of friends. In *Viewer* and *standing* apart, the people were *not* of his previous acquaintance: day laborers hired from a street corner and brought into the artist's studio, and so people of quite "other" social identities, ethnic/cultural backgrounds, economic class, etc. The ground of human and artistic interaction with the people was therefore very different; you might say the "quotient of otherness" varied significantly. Yet to us, the art viewers, the incidence of otherness is *open*—potentially even, depending on who we are. And the recognition of this level playing field amidst enormous human difference is perhaps the ontological basis, or at least starting point, of Gary Hill's ongoing inquiry into *projected otherness*.

In a 1993 interview (reprinted in *Tall Ships,* the second volume of this series), Gary Hill declares his commitment to the idea "that the art event takes place within … process. One has to be open to that event and be able to … wander in it and feel it open up…" He adds, "I'm getting further and further into finding this moment in processes that involve me with people." The identification of artistic process with the experience of encountering other people—a dialogue, even when non-verbal—is one of the roots of this artist's projective art, which, technically, is work that involves recorded video projected onto walls (or other surfaces)*. The "projective" is a rich and complex phenomenon, as we hope to illuminate in this

*This technical distinction applies to a significant number of Gary Hill's works. The actual beginning is 1987 with *Mediarite* and its later manifestations as *DIG,* both involving multiple

series, and what interests us most particularly is the way these projective works function as "meditations" on—or, perhaps "meditative spaces" for—the experience of projection itself, in all its senses.[†] Our inquiry into what could be called, broadly, the *poetics of projection*, proceeds from the concrete instance, the direct experience of specific works.

We see our writing here not as art criticism but as an inquiring process running parallel to the works in question, twin meditations, as it were. They extend our ongoing dialogue with the artist that began in the late '70s. It would be disingenuous to pretend "objectivity"—a critical value of little interest to us relative to this project; but neither do we pretend to speak *for* the artist. We only speak *with* him and with his work and its *projective possibility*. And *this* sense of the projective stands for the way the artist speaks beyond what he knows, outward into the space revealed by a work's further life—extensions of creative energy projected through its own instance.

GEORGE QUASHA AND CHARLES STEIN
JUNE 1997, BARRYTOWN, NEW YORK

projection and viewing devices. Then there is a new beginning in 1990 with *BEACON (Two Versions of the Imaginary),* in which full-scale human figures enliven a neutral surface, so that the space itself, the actual room, becomes the "projective" medium. In this same year, *And Sat Down Beside Her* involves projection of both live figures and text onto discrete objects, in effect animating, as well as textualizing, the surfaces. The next two years followed with *I Believe It Is an Image in Light of the Other, Tall Ships, Cut Pipe* and *Some Times Things.* The discoveries at the heart of this projective work have gained momentum in more recent works: *Learning Curve* and *Learning Curve (Still Point)* (1993); *Dervish, Remarks on Color* and *Circular Breathing* (1994); *Hand Heard* (1995-96); *Viewer, Standing Apart* and *Reflex Chamber* (1996); and *Midnight Crossing* (1997).

[†]Projection-related concepts have held a central position in many disciplines, including, for instance, psychology (Freud and Jung), mathematics (projective geometry), topography (Mercator's projection), philosophy (Martin Heidegger) and poetics (Charles Olson's "Projective Verse").

A Brief Description of the Works

VIEWER / 1996

5-channel video installation (NTSC, color, silent)
5 CRT color video projectors, 5 laserdisc players, a 5 channel synchronizer

Slightly larger than life-size color images of seventeen day laborers, facing out from a neutral black background, are projected on a wall, about 45 feet long, by five video projectors attached to the ceiling. Five laserdiscs (on which are recorded seventeen discrete images in three groups of three and two groups of four figures) are synchronized so that the figures appear to be standing side-by-side in a somewhat continuous line. (They recycle about every ten minutes, with no more than a slight blip between cycles in which the whole wall goes blank. In effect the figures are always present.) The men stand almost motionless, their movement limited to involuntary stirring—an incidental shuffling from foot to foot, slight movements of the hands, and almost imperceptible changes in facial expression. There is no interaction among them, each man standing quite alone and gazing out from the plane of projection towards the viewer.

STANDING APART / 1996

2-channel video installation (NTSC, color, silent)
2 CRT color video projectors; 2 laserdisc players and synchronizer

FACING FACES / 1996

2 20" monitors, 2 swivel wall-mount monitor supports
2 laserdisc players and synchronizer

(When the two pieces are shown together as a single installation, the synchronizers are linked.)

Standing Apart and *Facing Faces* are two linked video works, intended to be shown either together as a single installation (positioned at opposite corners of the same room) or as separate works.

Standing Apart involves two separate (slightly larger than life-size) color images of the same standing man projected onto two separate walls that meet at the corner.

Facing Faces involves two close-up video images, shown on two 20" color monitors, of the same man, in a view of the head and shoulders. The two monitors are turned toward each other at an angle slightly greater than ninety degrees.

The video images for both works were shot simultaneously with four cameras, so that the frontal view of the middle-aged, Native American man is actually the same, except for the focal lengths, which vary. In both works the effect is that one figure seems to gaze straight out at the viewer, while at the same time the second figure is looking at the first figure. About every two minutes the images switch positions: the second figure now gazes straight out at the viewer, while the first figure gazes at the second. This single change in the angle of the gaze happens once, followed by a return to the original position, and the cycle begins again.

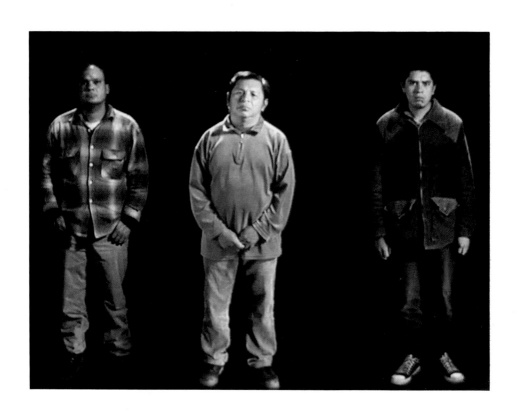

Viewer DETAIL (1996)

ON
view

When we enter an art space we implicitly choose the role of viewer, even when some sort of participation or interactivity is called for. The history of art is arguably some "volution" of that role—evolution/devolution/revolution/convolution—depending on one's model of cultural progression over time. In a sense every act of art "on view" challenges us to define the role of viewer, as well as the role of "viewed." Our presence is requested, so to speak, by the nature of the event. Yet presence, like viewing, is an unsettled notion in more or less continuous need of reassessment. This is a strange fact, given that viewing and being present are "activities" that we can hardly *not* be doing. Aren't they, like life itself, in some sense self-evident? Seemingly. And *Viewer,* Gary Hill's projective installation, serves as an arena of such self-evidence—and the self-questioning hidden in the heart of *view.*

Imagine that you are here paying a first visit to this particular art space: This is a place for people—a place *with* people. You come here out of a particular invitation, at least implicitly, since it is the tradition, perhaps even the nature, of art to attract, to invite. Here, the sense of the space is that you are coming to meet the *others,* the ones standing in a kind of readiness, apparently waiting for something, perhaps for you, the incoming outsider. Indeed, they are so *under*-specified that they may as well be waiting

for you. You encounter them immediately, as you enter, standing there, looking out from the long wall. They look at you, you look at them. This is a common beginning, or perhaps *the* common beginning, the way the world works: People coming upon people, and then one makes the *first distinction*[1] . And the story unfolds....

Whose story? Yours, ours, the guy over there. *These* guys—who are they? One's first effort is to take a good look, look hard, look 'em straight in the eye, size 'em up … and then? We dispose. We interpret the space and the people in it. We *take them for* something. All these standing bodies, faces on view—a line-up? An inspection? Slaves for sale? Captives facing a firing squad? What in the world could bring them here but the *law?* What calls them out has to be something very basic, if not the law, then raw need.

Or else art—obviously what brings *us* here. So we are people with a clear edge, people living as though we know why we're here, such is the power of the art-invitation to accommodate us in a space. People accepted in advance, for whom the first distinction is implicit; people who come bearing their own distinction, by force of the sheer declaration of ground-level value called *art*. A law unto itself, it has the power to call the people out.

And here they are: a room full of people, men against the wall, who are obviously not actors or professional models, such is the stance, and the look in the eyes. A just-off-the-street look. Clearly uneasy, standing intensely disciplined, as if to move is to be wrong. Men used to doing what they are told, at least the part we see, and at least in the confines of a designated space. Used to not knowing how to behave. Used to doing what it takes to make a buck. Yet—*this* is something different, and they plainly don't quite know what's up. What is up? Do *we* know?

Viewer

The Question

It's an odd, even awkward fact that when we gaze into the eyes of individuals among the seventeen standing men of *Viewer*, we quickly find ourselves in the state of *inquiring*. Perhaps this state is the inevitable result of a pervasive mood of uncertainty—in their eyes, in how they stand. There's an impulse to question them—who are you, where do you come from, what are you doing here, what do you want from me, how did you get into this situation…? *On view* here means *on the spot*. Yet *who* is on the spot is part of the question. The mood of uncertainty is contagious and soon becomes a mode of presence in the space.

Everyone's a suspect, all are under suspicion. The kind of distinction one draws in lining people up this way reflects how we set ourselves and others apart, and participates in a history of apartness. No one feels particularly safe in this situation, neither the one on view, being stared at and suspected, nor the one viewing, inquiringly cutting into the space of the other standing there. Unsafety is on their faces, a look learned and adapted to handle the state, the modus operandi of everyday on-the-spot identity. And we, as viewers, just keep looking on, fixing the face of the one standing in front of us, facing us. We quickly develop our own mode of standing apart. It's a matter of the survival of the identified, because by a sort of law of reciprocity in uncertainty, the

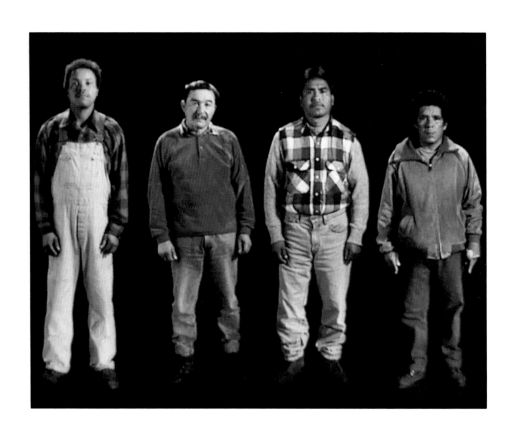

Viewer (DETAIL) *1996*

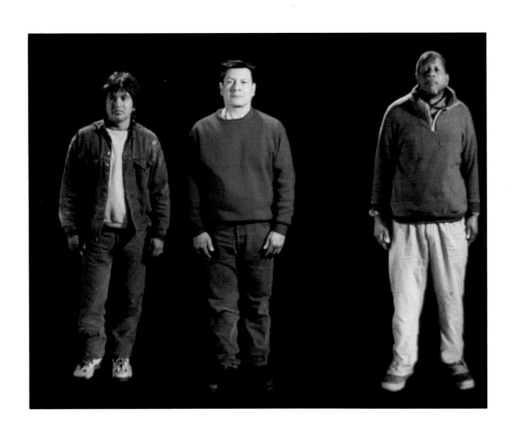

Viewer (DETAIL) *1996*

inquiry moves in two directions at once. An identity adrift in the space of the viewed soon cuts across the safety of the art space and feeds back into the state of the viewer. Art may be in question, or, at the very least, in the question. (Might it even have been beside the point?)

What we are in the midst of here is *viewing*. When we came into the room what we happened upon was *the view*. A room with a view, *inside*. The view is people looking *out* from where they are, *in* to where we are, here, in the middle of the space. It seems, perplexingly, that the view itself is viewing—viewing us. Or, by a turn of phrase (a shift in view), viewing itself. In an environment that is saturated with viewing, at a certain point it's as though the space itself views—a topological displacement of agency, a spinning out of grammar in the active relationship of entities in the space. It quickly gets confusing, and it is hard to believe one might be thinking: *the view is viewing itself*. The thought is a kind of trap. To dwell there risks getting lost in the rainforest-like heart of the question: the thicket of identity in the two-way act of viewing. Even when one-half of the equation has the status of *the illusory*.

Who, then, is the viewer? And what constitutes the view *concretely?*

Projectivity

The view is, at any given moment and in quite different senses, a projection. There's always someone behind it giving it specific life. And the medium itself is projection, which means that some*thing* is being thrown out into "viewing space." In this kind of space there is a reflexive relationship between the thrower and what is thrown, with continuing feedback governing the interchange. And of course the context in which we

make these distinctions is projective art, which is a conscious—meaning responsive and responsible—working within the generative field created by the possibility of projection. The nature of this possibility is as complex as it is attractive, and this becomes obvious when we venture into what projectivity actually gives rise to.

One thinks immediately of the moments of "hyperrealism" that occur whenever a genuine connection is made between viewer and projection—whenever the *person*-factor is truly active, as if there really is someone *there*. This domain of interactivity was the mainstay of *Tall Ships* (1992), in which a direct encounter—a coming to meet—was foregrounded. Given the quality of the experience, it becomes necessary to remind ourselves—as we will do again later in these pages—what it is we are seeing. No one's fooled when a video projector casts the image of a person upon the wall—and yet, it has its own reality, its own *intensity of view* that is evidence of intentional projection. *Tall Ships* was instructive in showing how little the "high tech" aspect (ever new gadgetry) determined the force of the effect. Indeed, we have reported specific viewers' comments on the specifically psychological or emotional power of the experience of meeting "others" in *Tall Ships*[2] .

The point is that in an optimal viewing of projective art there comes a moment when a special reality erupts in viewing space. It may well be the "realer than real" experience so avidly sought in the world of special effects or some other verisimilitudinous escapade, but this is hardly the aim or the register of Gary Hill's art. The "realistic" is incidentally a value, to be sure, in a work like *Viewer* as an aspect of appropriate attunement in the medium, which in these projective pieces aims at invoking certain qualities of presence. That presence is certainly dependent to some degree on "looking real," although in *Tall Ships* the soft focus (due to small black and white monitors projecting

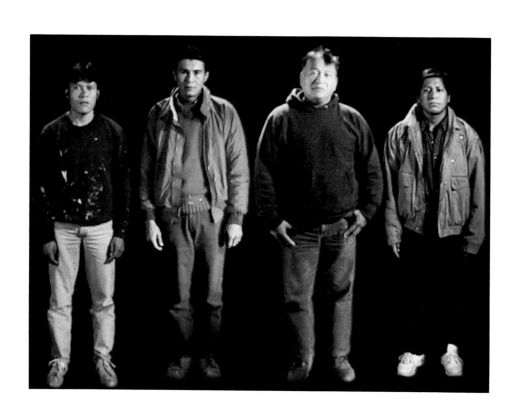

Viewer (DETAIL) *1996*

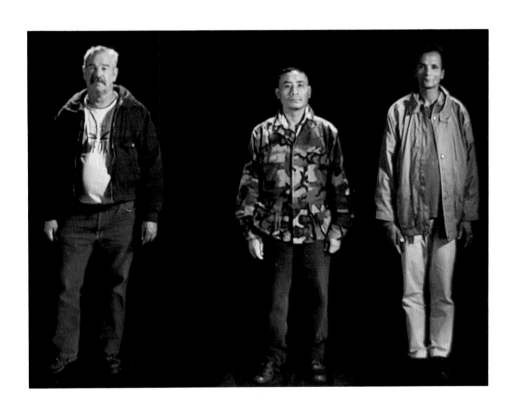

Viewer (DETAIL) *1996*

through cheap lenses) created an almost ghostly effect. The experience of presence and even the hyperreal—perhaps hypersensual[3] is the truer word—is highly particular, a matter of *concreteness* and *focus* within a declared context that carries a certain charge.

Focus

Eruptions of "the real" inside viewing space depend upon focus, but not necessarily by way of a lens. Interestingly the etymology of "focus" is Latin for "hearth, fireplace," implying the meeting point of rays, and in Kepler's time a "focal point" was also a "burning point." This reminds us of the physicality of focus as *convergence*—a coming together that ends in flare up. It has great metaphoric potential for our thinking about the aims of projectivity as the ignition, by way of light, of a hypersensual reality—a middle-point, a shared verge, where the projection comes to a "burn." It's as though there were an axial point in viewing space where projection turns around and comes back at the viewer—their eyes, carrying perhaps the suppressed heat of their alienation, reach us. Metaphoric combustion may help us declare the territory through which we would like our inquiry to lead: A special sense of presence through the possibility of conjunction.

View, viewing space, the viewer's state of presence—key notions that we do not *define* so much as *invoke* in the interest of sustaining an inquiry—are all linked to the matter of focus. In *Viewer* the projection of the seventeen figures is very sharply focused (from an optimal distance, which is not close up to the wall). And as one engages this concrete focus, there is a personal charge relative to each of the men as one views them discretely; this is a *human* focus, a kind of individuation of attention. Then there is

the *interactive focus*, by which we mean the phenomenon of focusing on the image of this *other* person in such a way that we ourselves seem to *get focused.*[4] This may be something like the interpersonal equivalent of "virtual focus" (the point from which divergent rays of reflected or refracted light *seem* to emanate, as from the image of a point in a plane mirror), a focal entrainment in which the sensory attunement pulls along one's whole being. This in turn produces a *field focus,* activating the whole of the viewing space, so that the shared sense enlarges and the other figures come alive in new ways. And in so many ways what shows up in this hypersensualized space is how these quite simple and ordinary people, whose living and breathing images are pro-jected on the wall, are in fact quite powerful presences—unavoidably engaging and almost eerily present presences. Yet they are merely projections.

Projections of whom or what? The artist? To situate the artist relative to the projec-tion we must determine who, which may mean *where,* he is in this art. He is of course not anonymous, but he is in this work somehow an artist *of* the anonymous. His cam-era has recorded the full-bodied presences of seventeen individuals hired off the street, day laborers (working here, as it were, by the minute), whose identities we have no way of knowing. If we met them, however, we'd almost certainly "know" them, that is, recognize their faces—and maybe more. We do carry these projected faces away with us, so powerful is their presence. And we might be tempted to say: so powerful is the projection, or the art—the view. Because the art is in more than one sense *projective.* And the artist is in the projector. He did his work with a camera, but his art is in the projector—the machine and not the machine; the light, and not; and... the image? Certainly, the very powerful image of real and living and surprisingly *moving* presences of individual people, but can we really call it an *image* when what we are looking at is so

committed to the genuine presence of living, breathing human beings? Perhaps we should think of it in relation to something like *seeing a ghost!*—because if that happened to you you'd hardly say, "O God, I just saw an image in my room!"

> A ghost that fails to tease belief
> is hardly a ghost at all.

The order of experience we are speaking about is not, in short, well served by the notion of image as we commonly use it.

Committed Neutrality

The camera is neutral here. It is the tunnel of vision through which living presences move, a threshold of viewing. Its neutrality is not a matter of objectivity or aesthetic distance or dispassionateness or indifference—but clarity and awareness and, yes, presence in the face of presence. This projector is the custodian of artistic commitment. It stands firm for the living presence that it maintains before it. But it is neutral in that it does not interfere with what it sees; it does not interpret. Artist becomes Viewer, initiated in the viewfinder and conjoined with the looking-backness of the viewed, a "natural reciprocity." Reflectively, reflexively, we, the viewers of the found view, are not interfered with. We enjoy the freedom of the *still point,* freedom of mind in the matter of direct vision[5]. In this viewless viewing space gathers the inscrutable matter of presence without context and without distraction—presence without reference and without manipulation. Whatever stands seemingly stands revealed and revealing.

Emergent Identity

Who, then, are *these* viewers, whose eyes follow us as we walk by? Who are the viewers in the view we are viewing? Inhabitants of the personscape of evident ethnicity—and they are so *very "ethnic."* Inescapably and obviously unmelted nativity-bound identities. Yet *not*. Because it doesn't take long, looking them straight in the eyes—where else, in such an austere personscape, is there to look?—to lose track of their categoricity in the white man's mirage, the mental brushstrokes of *black, hispanic, native american*—the heavy matter that weighs down our collective senses, the gross projections that issue from the dead artist inside us…. It doesn't take long for them to shed identities in the open space of committed projective neutrality, the inside view, where even they, the over-defined "minorities," settle down into *zero grade humanity*[6] , the base line of identity possibility. Free of context—the whole world of projected vulnerability, aggression, terror—free of the kinds of projection that are like a net cast over their lives from the white man's gaze, and still reflected in their eyes.

The view in the viewer's viewing has its own time. Its disposition is steady and impassive. Its passage is the unwavering stance of the camera/projector, of the "subjects" themselves, and of ourselves disposed to gaze upon their presence. As we listen to their silence, we track with nerves (and whatever other extra senses) our own thoughts and projections. Perhaps we discover the radical alignment of subject and camera as we work ourselves to arrive at a still point in common: the threshold of emergent identity. Is this a space in which history opens into view? Is there an optimal conjunction in which the sudden manifestation of shared presence is transmittable?

Whatever the thought, a certain projective silence enfolds the presences.

Notes to "On View"

[1] This term, like certain others that we will mark as we go, has for us a special meaning:

In the mathematician G. Spencer-Brown's fascinating 'calculus of indications,' the act of making a first distinction is taken as a *founding act*—the event of something's coming into being—any "world," such as a discourse, a cosmos, a context of perception. The event embodies its distinction from everything else. Spencer-Brown gives the example of the act of drawing a circle that separates a space into what is inside the circle and what is outside the circle. Everything that follows, that is, any other distinction, is conditioned by that first distinction. Similarly when a person comes upon another and makes "the first distinction," all further interaction is conditioned by it.

[2] The second book in this series, *Tall Ships: Gary Hill's Projective Installations, No. 2*, discusses these issues at length, and they are further discussed below in "Projection: The Space of Great Happening."

[3] We borrow the term "hypersensualism" from the anthropologist Richard Sorenson. He uses it to represent a state of being that certain native peoples in the South Pacific apparently experience as part of their ordinary, everyday relationships—a state of intensified flowing sensuality that is not limited to the purely "personal" dimension but is a kind of global energy field engulfing all the senses. The hypersensual serves not only as a means of pleasure or delight, but as the actual medium through which interpersonal communication is conducted and social order maintained. Apparently it is a species of *sensual focus* that functions without the mediation of semiotic coding usually associated with tribal sociality, and yet it is interpersonal, directly communicative, precisely understood and sustainable. Unlike ordinary sensualism, it may belong with the "awakening" forms of awareness, such as meditative experience. The value of the *concrete* in such experience may be understood as an opportunity for "hyperfocus" or meditation, particularly in the "bare awareness" traditions of Ceylon, Burma, Thailand and Tibet. These practices involve the attainment of extremely intensified states of awareness through the focusing of attention within the most concrete aspects of psychosomatic existence—bare sensations. We

are interested in the possibility in art that certain orientations of viewing space may invite spontaneous hypersensual or hyperempathic experience.

[4] An aspect of focus as applied to one's own state of attention or awareness is the whole domain of the *practice* of focus as a psychological or meditative tool—a vast and rich domain in itself. There are many possible applications to our thinking about the way artistic focusing happens, especially where issues of the "mind-body" connection (we would say "liminality") are foregrounded. A major development in the theory of "focusing" can be found in the work of psychotherapist Eugene T. Gendlin: "[Focusing is a] mode of bodily attention [that] differs from the usual attention we pay to feelings because it begins with the body and occurs in the zone between the conscious and the unconscious…. A bodily sense of any topic [that needs examination] can be invited to come in that zone." (*Focusing-Oriented Psychotherapy*, The Guilford Press, New York: 1996). Gendlin's "focusing" accesses that *liminal* zone between the conscious and the unconscious for the sake of generating transformative insight. Artists, composers, poets (e.g., John Cage, LaMont Young, Jackson Mac Low, Franz Kamin) and others have proposed innovative extensions of focus as the appropriate "state" of experiencing their work. Cage called this special mode of attention "unfocus" and related it to Zen; in a related sense, we can speak about "field awareness" and so on. We are suggesting that Gary Hill's work be thought about in this tradition of innovative awareness.

[5] "Still point" will be familiar to readers of T.S. Eliot's poem "Burnt Norton" (the first poem of *The Four Quartets*), section II: "At the still point of the turning world. Neither flesh nor fleshless/ Neither from nor towards; at the still point, there the dance is,/But neither arrest not movement…." This vision of suddenly realized timelessness ("To be conscious is not to be in time") derives from Dante's vision of eternal stillness in the last canto of the *Paradiso*.

[6] We borrow "zero grade" from the descriptive terminology for typical morphological processes in Indo-European etymology, where "zero-grade form" is a form with zero vocalism—the most "open" minimal form because the least "interpreted" and simplest. Zero grade is the last point before the root loses its identity altogether.

We use *zero grade humanity* as a distinction from early modernism's "mass man," where universal theories accounted for humanity in the aggregate and the individual vanished in the crowd. Tellingly, none of this seems to apply to the men in *Viewer*, even if we see the line of them extending indefinitely to ring the globe. Indeed, these men *might* seem to "stand in" for humanity at large, but here the human aggregate is ontologically undetermined. We don't know what we are, individually *or* collectively. *Viewer* shows how, in our time, the "mere" individual stages a sort of comeback, if only because the invidious comparison between the human unit and the teeming multitudes now seems as arbitrary a measure as any. But this comeback is hardly heroic; the individual returns as the enigmatic yet sharply outlined figure of singular, brute sentience, naked thereness, and ambiguous potentiality.

REFLECTIONS IN PASSING

*In the first installation of the pieces—*Viewer, standing *apart, and* facing faces—
*at the Barbara Gladstone Gallery (November 17th, 1996 to January 18th, 1997),
one entered the first installation,* Viewer, *walked the long room in which the
facing forty-five foot wall was completely filled by the projected line of seventeen
men, their bright full-bodied wall figures slightly reflecting on the floor; then
one exited from the far end of the room. Next one crossed a sort of hall and
entered a small room containing* standing *apart—a full-sized projection of a
single figure (doubled) straight ahead in the far corner—and* facing faces—
*immediately to the right on two monitors (in the opposing corner to the full-sized
projection), showing the same figure, again doubled, in head-and-shoulders view.* *

**Shedding identity in a responsive space
disposes living at the threshold.**

ONTONONYMOUS THE PARTICULAR

From room to room

and face to face, the focus of the spaces is specific to a quality of light that plays across
the visages of the viewers, always in different positions and in different relations. It's
the *others* there in the room, fellow travelers, who stir the energy in the room, some-
what as in the earlier installation, *Tall Ships. We* were the ships with moonlight in our
sails, light borrowed from reflective faces on (in) the walls (the distance). To "identify" in

HanD HearD was also on exhibit in an adjacent room; but we ignore this work here, since we have discussed it
at length in the first book in this series, in relation to the inaugural exhibition at the Galerie des Archives in Paris.

this way with the journey of others gives us the sense of shared view, what it means to be there together. To navigate by borrowed light. To get a feel for the consequences of "having a view" as carrying the light by which any view happens. How a given view feels in the body, how a look hits us, how deeply a gaze penetrates—how having *view* can be like having *vista*. And the lack.

Standing apart

—no matter what we feel—apart from the presence, apart from *them*. Presences have a built-in strangeness, like apparitions. Now you see it now you don't. Clouds across the face of the moon. Whole lives are lived in this condition, you can see it in a face. A face in the street, *from* the street, a street face—a face that belongs to the street, to the point where you might say: This is *the face of the street*. How many of *these* faces, these stunningly present beings—the seventeen of *Viewer*, and then this other one, this instant classic of a human being—how many would you stop to look at or otherwise engage in their "natural" habitat, The Street? Here we view them in the safety of art. We look them straight in the eye, without fear—but not without the distinctions. Distinctions unfold of their own accord, erupt from our past, from history, from art, from the dark. We project. We lay it on. We meet their silence with a secret story, and no one will ever know. We, the artists, the viewers, the projectors, here together, perhaps, for the opportunity of a special awareness.

Now this single

(double) figure of *facing faces:* He has some special kind of awareness, this man standing apart from us, the world, and standing apart from himself: He looks out at us, like the seventeen previous viewers, and he stands apart from himself, and looks back at

himself. A complicated moment, this near reflection, this doubling—not quite like any other, except perhaps in a dream. But we can imagine this moment very well. It might almost seem to be inherently a part of oneself. My other, my twin, my almost me, brotherly semblable, my always making distinctions as regards myself, alternate awareness, mirror of my being, inquirer, disposer…. Notice that the view keeps shifting, one moment the viewer, the next moment the viewed—the view. He stands apart from his own view. He stands apart *as* his own view. The switch.

Projector switch

—the on/off switch of the artist (mind) as camera, as projector.
The voyeur/disposer switch.
The back-and-forth oscillation of dualistic perception.
Self-reflection/self-deflection.
The watcher watching the watcher watch the watcher.
All the borrowed light and borrowed rights in the world never seem to keep us
from standing apart.

Every time his gaze switches

he seems to be once more trying to get back together with himself, give it one more try. Something so sad and longing in the look. Something noble in the look that has taken a step back from himself, one small step for this man reflecting a giant step back for humanity—for "his people." This is the face of a man with a deep sense of having a people. A shared sense, but without much certainty. A tie to the tribe with a loose end. A switching end, a ragged two-taled flag, but the home end still somehow tied down inside. The face shows the man has a center, a view still looking *in* as it looks you in the eye.

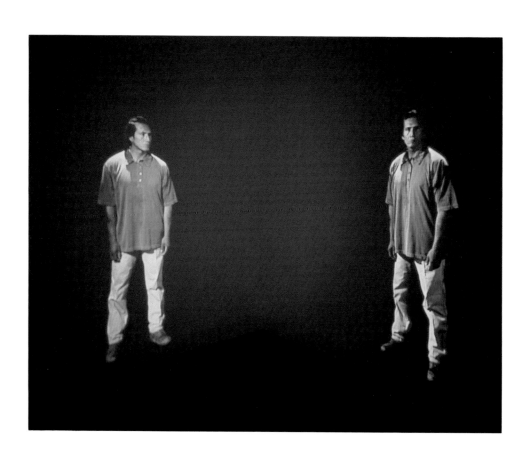

Standing Apart (1996)

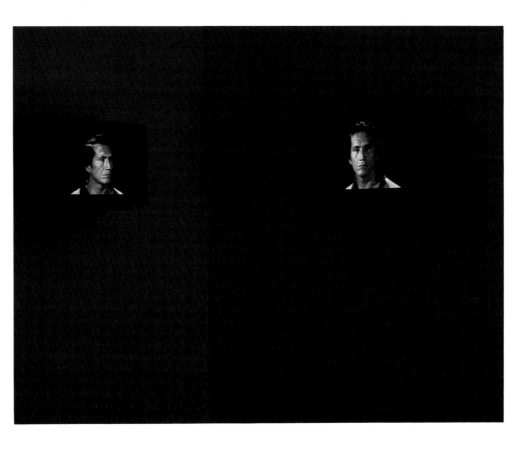

Facing Faces (1996)

But he left his context at home

and the artist has let him come here alone, standing apart from his world, his losses, his political residuals, his psycho-social net, his gap—our gap, always already there for him. He's here alone, standing apart alone, and our link with him seems inseparable from this aloneness, this apartness. We are implicated in his self-reflection.

Are we looking at a portrait

there on the wall? Is this a *picture?* A distant, perhaps ironic cousin of Curtis' vivid portraits of "Indians"? Or, for that matter, a relative of any number of European and American photographers' stark slices of like-it-is life…. One thinks perhaps of Avedon's pictures of unbearably immediate indigenous *others*…. Maybe the related sense of presence compels comparison or unavoidably crosses the mind at moments here. But the differences are fundamental. Here portraiture itself comes into question. The very presumption of *looking at* is uncomfortable with itself. In a portrait—painting or photograph—or picture *of* someone, the time of portrayal is either the time in which the portrait was made—the historical moment—or else the time in which it is viewed, and there is no confusion between the two times. The time of the portrait is truly *other* to the time of the viewing. In contrast, this life-size projection of a living, breathing entity imposes a time of its own which is unrelated to the static time of portraiture. It exerts the pressure of a "real time" that, although it corresponds to the actual time of the artist's "composition" (a real-time video recording), its circumstances, social-cultural context and subject identity are obscure:

it floats freely in the time of viewing

Its time becomes our time as we view it. How could it be otherwise? The presence in front of us may be quite still, but it is moving—you see the presence moving in itself. We register such movement in part with our own emotions—not necessarily feelings about the one viewed, but about *anything*. We are aroused to the intrinsic movement of being here—and being *there*. There where intimate living is going on. And somehow this confusion draws us into its time as the time of our own otherness. The degree of absorption—the inevitable intimacy that itself stands quite apart from the safety of portraiture, indeed of Art—is disturbing.

In real intimacy

there is reciprocation. *Tall Ships* performed the action of coming to meet—the presence got up and walked right up to you. They, the people seated and waiting in the wall-world, got somewhat intimate on your behalf. In this recent series of works, beginning with *HanD HearD* and continuing with *Viewer, standing* apart and *facing faces,* the space of choice is pervasive. Everything returns to the middle ground, the zone of disposal.

The locus of viewing

is in the middle. It has a voice and syntax all its own. For all the power of presences, they are only part of the field. Who can even be said to be there as such?

<div align="center">

One who sees

being seen

</div>

<div align="center">

～

</div>

According to Marginal Man

the torque of saying
who you are
turning into
speaking
itself
talks double
when in trouble

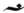

Getting up close

in the movement from space to space, the eye-to-eye lock-in is somehow optimal—a condition in which things get to be just what they are. And that's rarer than it sounds. Indeed it's *radical*. A condition, as the poet Charles Olson put it, in which

nothing is anything but itself, measured so.

And in a sweep through these rooms, we are closing in. A kind of hyperfocus. It is we ourselves who find the focus, as though identity itself—personality, personal boundary, life style, social status, self view—were a matter of focus. Perhaps with a mere twist of the focusing apparatus these presences would transform before our eyes. Perhaps they do anyway, and the longer we stand there, alternately apart from and a part of what we

see, the more the focus, the view, the projection becomes its own *other*, our own other, its and our here-and-now emerging possible being there together—what it really is. Without preference, neutrally disposed, open to what shows up or shows through—the optimal view.

This is a way of seeing

what's there and who's there. It takes into account an implicit syntax of the space, a certain textuality in which our presence performs grammatical function. We get to see the kind of verbs we are, what our subject does to other subjects, what pronouns we dispose as mere nouns (people turning into things) as we project our stories upon their inquiring faces. We get to face the faces, and in *facing faces* we come in close on *standing* apart, and we see the very face, the face itself, nothing but the face so help you God, so effortlessly itself. It lets us be soft to know it, this might-have-been heroic (but for our world) visage. Here in middle earth it all comes down to the same, just who we are here, the big monitors casting a very different light on our faces. We turn our heads (in *standing* apart we turned our whole bodies) to catch a glimpse of the other face, to switch with the switch—the dance here is all in the head, the place of the face.

The aspects of the view

are like facets of syntax. Facing the face can mean facing the music. Can *to face* be the contrary of *to efface*, and is there something between these two that true facing does?

standing *apart*

facing
faces

A Projective Twin Installation

The poem is the cry of its occasion,
Part of the res itself and not about it.

WALLACE STEVENS, *"An Ordinary Evening in New Haven"*

Not all angels fly—at least not anymore. Angels gaze. They locate a
world and gaze into it. Beyond that, it's social—degree of contact,
consequences of connection and lack thereof. If the face faced is
somehow the angel's angel, then reality shows itself as our mirror,
and we ourselves are reality reflected.

ONTONONYMOUS THE PARTICULAR

The Work

In so many ways a work bears the stamp of its *occasion*, how and where it "falls" into being. This fundamental truth about human work of course has unlimited specific valorizations in art, from a traditionary sense of act/artifact as manifestation of the energy of place, to variously "open" intentionalities—found art, happening, aleatoric composition, site specificity, and so many unnamed discoveries. The fall of the dice, the throw of the dice—the subtle membrane between chance and intention resonates in the dialogue between the occasional and the projective. This fluctuant polarity reflects a profound issue in our sense of a role in "creation" in the broadest and narrowest senses—how much to accept the "given," how much to launch the project from scratch. When Gary Hill tells us in so many words that the "site recites," he invites us to listen right there at that edge, where identity and environment, entity and field, call each other into crisis.

The notion that people standing where they are have something to say just *as* they are, has been a foundational perspective in Gary Hill's work at least from *Tall Ships* (1992) to *Viewer, standing* apart, and *facing faces* (1996). We call it a "perspective" because it's hardly a fixed value; it's rather like a declared space in which an angle of incidence in the intersection of occasion and projection momentarily come into concrete view. The artist sees certain men standing on a street corner in Seattle and invites them in to the sharp focus of a camera in his studio, and suddenly there's a threshold. What crosses that threshold is utterly open, because of the fineness in the managed space between the raw givenness and the intensity of the artistic gaze, as the two cut across each other's "alien" domains. Whether it's an angel or a devil at your door depends on many factors, which is to say that the distinction is anything but clear. It might come down to *use*, how we dispose the available.

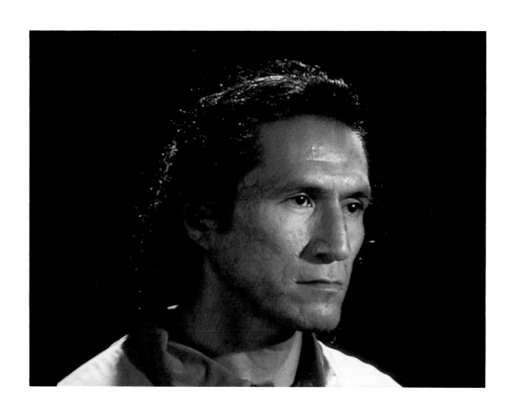

Facing Faces DETAIL *(1996)*

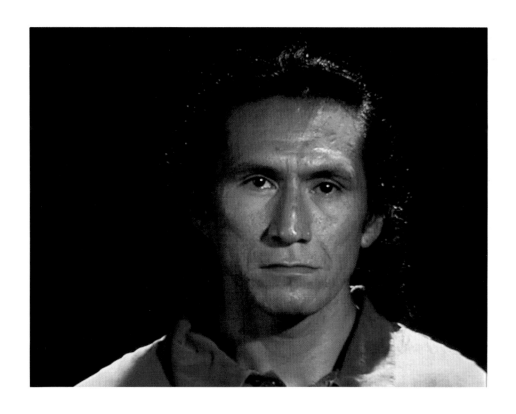

Facing Faces DETAIL *(1996)*

Let us suppose, for this occasion, that we do have a say in the matter, and that accordingly there is some gain in our declaring a certain mode of access to this threshold situation: We call the work at hand, *angelic activity*. Instead of pretending that we know with certainty what the function of art is, we can view it anew through a question: What is this particular angelic activity? And the next step is to tender a working hypothesis: Angelic activity is what makes palpable the angel's *subversive logic*. What then remains is to experience, firsthand, the work's particular logic and its activity of subversion.

This mode of access makes it appropriate for us to proceed *paratactically*, by the "neighborly" principle of order, allowing experienced language to lay down its statements "side by side." After all, the Gary Hill work before us comprises a projection of the same person side-by-side with himself[1]. And, by a structural coincidence worthy of being called poetic justice, the name of the group show at the Kunsthalle in Vienna that has elected to include this installation by Gary Hill is: *Angel, Angel*[2]. Indeed, the very effort to make sense of angels *logically* can only end up putting us beside ourselves. Perhaps that's the most advantageous place to be, if only for the *view*—Peripheral vision, the sense of vista, and the anomalously broad meaning of *place to be* that includes the full range of one's experience of complex identity.

If this question of "where we should be" is relevant to the work by Gary Hill that we are here "viewing," then we will not be surprised to find ourselves returning again and again to the issue of *doubling,* or perhaps we can say *twinning.* In one ancient tradition of angels, what you see is not the angel himself or herself but his or her twin, the earthly double, the art self. And if you see him or her at all, it's because your own imaginative projection of an art self (or art viewer) is up to the challenge of seeing or (en)visioning the angelic, the radically other as information source. In this sense, it's not just a matter

of "what you see is what you get" but of what you see is what you are.

However, we should not stray too far from the question (as to the nature of this activity), because the angel as messenger[3] may not be the bearer of a message so much as a mode of inquiry: How about looking into the eyes of reality like *this*? What is *this* angelic reality? Let's call him by the name Martin. And despite the etymological implication that its bearer may come from Mars, which would support the visual evidence that he suffers the fate of *aliens*, he is very much from and of the planet Earth. Tellingly so.

> *Yet I am the necessary angel of earth,*
> *Since, in my sight, you see the earth again,*
>
> *Cleared of its stiff and stubborn, man-locked set,*
> *And, in my hearing, you hear its tragic drone....*
>
> WALLACE STEVENS, *"Angel Surrounded by Paysans"*

The Other's Angel

Simplifying matters for the time being, let's say that we come to the place of art in the hopes of having a "close encounter," whether of the opening-night body-to-body *social* kind, or the head-to-head *sublime/subliminal* kind, or else a kind between these, *liminal*[4] to the social and the sublime yet direct, the eye-to-eye. The art site, as we noticed in relation to *Viewer*, is a place for people—a place *with* people—that invites us to meet an other who seems to be waiting for us. Meeting *him* right away, as we enter, looking at

us from the wall (like the seventeen men from *Viewer*)…*looking at us… looking at him…* our mutual attention *marks* the space, once again makes a *first distinction,* and gives rise to the unfolding story:

> *A man is gazing at himself gazing at you the viewer. What's up? A man is staring at a video image of himself which stares you right in the eyes. But* [one realizes, pulling back from this unrequested, improbable state of intimacy] *of course the man is not a man. He is a video image.*

Alternatively: He is an *angel*—code word for *liminal identity*, the face of/in the medium, figure of the marginal man, being at the threshold (either poised for a bold entrance or locked out in the cold), facing both ways, connector of worlds, mediator of incommensurable realities, transmitter of the *one* to the *other* or balance point between two sides of the equation/inequation (holy/unholy, healer/infector, savior/destroyer, etc.).… When the story unfolds paratactically the known and the unknown find themselves to be no longer opposites but sudden neighbors.

"Normally"—in a familiar context—a man looks at an image (as opposed to an undistorted reflection) of himself, video or otherwise, and through the nature of the medium the image looks different from himself. (This is a near neighbor of the experience of hearing a recording of one's own voice, which through any medium other than one's own body sounds alien.) Here both the "man" and his "image" are present in the same medium, wherein he seems to negotiate with his own image, as it were, on equal terms. The longer you stand at the apex of an invisible triangle with these "two" (Martin, Martin) the stranger it gets. This is the medium, after all, whose *real-time* nature so intensively, even notoriously, renders an experience of *presence*. This degree of experienced

presence (dare we say "apparent presence"?[5]) might well seem uncanny were the medium not *invisible* due to over-familiarity (like walking into a room with the TV on and not noticing at what point it takes over your mind). It thus seems that an impossible thing is happening. That is, a man is present to himself externally as an other.

By this subversive logic he can only be an angel. And "it follows": Anyone who sees an angel is other to himself.

⤶

> *And here we all are, witnesses in common*
> *released into a darkened clearing,*
> *catching the ambient light in a makeshift sail.*
>
> ONTONONYMOUS THE PARTICULAR

The Encounter

You enter the space in which the corner contains a double presence, two male figures, full-size, one looking at you—his eyes seem to track your approach—and the other looking at the first one. They are obviously "the same person." No sound, no words— only, perhaps, the quiet resonance of a title that promises no indication, no attitude toward this untroubled yet self-evident disturbance in the logic of identity. There is, within a few minutes, an action: The roles shift—the two heads rotate some forty-five degrees, turning the one looking *out* into the one looking *at* and vice versa. A few minutes later the action recurs and the roles revert. Caught in a triangle of shifting view,

you stand at the apex of a slow oscillation in which you yourself have an unspecified role as the witness of a performative event: A sort of spatial-grammatical shift that is as much synaptic as syntactic, a redirection in the arc of energy, a periodic re-inclination in the communicative leaping across…—Could this serve as a bare-bones model of how human communication *performs itself,* as a direct projection, something like the transmission of a charge or an emotion or a substance or a disease or a state…? Yet no evident intention or message or "language" manifests as such. Still, something shows through. Something human, something like pure human space, and something, too, like the empty yet subtly *surgent* field beneath language itself, its *urge*, its *ur-*, from which it arises with an unaccountable periodicity.

The Mark of Distinction

To be present for this performative[6] event is to register its inherent but unstated question as to what it is to itself and to its world. You look into Martin's eyes and they tell of themselves and inquire of you. He meets you in the space between. He is *only* between—himself and himself, himself and you, and the world. Like the angel he stands here in the middle. Apart. This is a distinction in which you participate, in a sense, involuntarily, a distinction that is made by the fact of your presence in the space. The apartness is there before you, like the fall. You can't recall creating it or agreeing to it, yet it makes no sense not to accept that you belong to it. It's *as though* you had created it, and as though a certain amount of research would reveal your role in engendering it. You are marked by it, and it has your mark on it. Already. Apart *from whom* is not clear, or not quite the point, but in order to notice the apartness you are in jointure with the

property of separateness, an outsider gazing in on your own dislocated world. It's as though there were a legacy here, characterized by dispossession, alienation, something tragically native to the land. Something palpable, like what you can dig down into. And get your hands dirty.

Standing apart is a function of this communion with the viewer,[7] a deeply and fundamentally alienated communing. It carries within it a question with the force of identity itself. Perhaps it is this question, this quest, that we associate with the angel and his subversive activity insinuated into the sinew of our communing. What shows from it is that we are standing on common ground in our apartness, which may well be the strangest thing about it. A direct message from a non-flying species of the *engrounded angelic*: that however other he is, this man Martin, however silent, empty of self-assured gesture, however remote his particular problematic of existence, his self-interruptive presence, he carries a charge, mantic in its way, telluric rather than "verbal" in its messaging. It tells more than we care to hear.

With the angelic you always get more than you bargain for; if you're not careful you get saddled with the message, rather than just receiving it or knowing it, as clearly we would prefer. (Rilke put it harshly: Any angel is a terror[8].) The "angelically engrounded" artist takes on more than he knows, and as perilous as this is as a way of life, it suggests a principle at the root of his secret power: to make works that speak beyond him. The work taps a source, wherever that source comes to the surface. The point is of course not a matter of the artist's belief or conscious intention as such or philosophic/religious orientation—crude distinctions at best—but of the force of his reach into the revealing particular. The other side of "standing apart" is the *retention of "beingness"*—[there is no help to be had from ready-made notions here, so we appeal for tolerance as we try to

say the improbable]—and the consequent *projective possibility* that arises spontaneously from the *space of the stance*. To stand not with but truly *in* the one who stands apart, is to take on his unrealized possibility, perhaps to nurture it in the dark light of its wound, to know its unspoken angel, to do the work for that angel that it cannot do for itself—this is an angel's activity, a leap across the gap of its historical distance, its lapsed social lease, its tragic incompletion that sets its Martins to ruin because the dying art-beings inside us have lost the power to come fresh to such an *other.*

The failure of our language—its standing-apartness from itself and whatever in the world would have us speak for it—is not so much a theme of Gary Hill's projective works, which recently have stepped back from using verbal language as such, as an implicit condition of their emergent functional principles, which the present discussion is an attempt to draw into view. He seems to have discovered a modality of

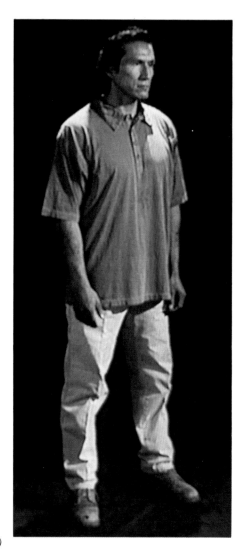

Standing Apart DETAIL *(1996)*

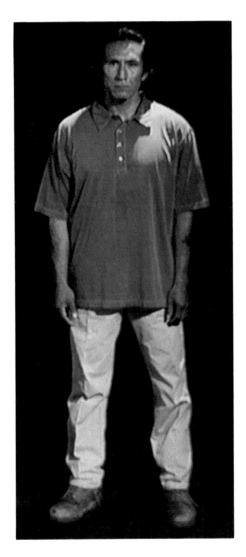

tapping the space of linguistic "failure" by stripping it to its residual kernel of power and setting the linguistic in the space of its own, and actual, silence. Martin "tells" even if he doesn't "speak." The connection between the present installation and Gary Hill's earlier work, *Tall Ships*, is the way in which he transferred language function to the participation and actual presence of the viewer, by causing a meeting in silence between a projected being and oneself (the viewer). Here, so to speak, the work stirs up human connection—at something like the level of zero-grade humanity—and causes contact with the *optimal minimal* or precise point at which human sense is restartable (as yogurt is started from a culture). This is subversive activity. It undoes the safeguards against the release of the uncontrollable possible human, which, according to "angelic logic," is primordially— but hardly actually—free. Martin is the site of the angel caught in the tree of history. His world is a giant No Fly Zone.

Standing Apart DETAIL *(1996)*

standing apart is a transmitter of raw signals—news from the backroads of engrounded angelic America and its silenced nativity. In the role of viewer, we mark the space as we read the signals and, at any given moment, cause our own distinction to take hold in the space of the work. If we meet it at the level of its and our own potential, we create an *optimal event*, a "reading," and we angelically carry out the *further life of the work.* We meet Martin, the man on the verge, out on the verge—at the point of his sole known opportunity to go beyond where he is. Gary Hill may not have realized what he was getting himself into when he did it, but he followed certain unarticulated instincts and reached out of his world and into an *other* one. He has touched something essential *to* and *of* the land.[9] And how interesting to think of such a work installed in a place like Vienna—like importing coyotes.

—Hypocrite lecteur,—mon semblable,—mon frère!

CHARLES BAUDELAIRE, *"Au Lecteur"*

...and he stood
in this room–it sends out
on the path ahead the Angel
it will meet...

CHARLES OLSON, *The Maximus Poems*

The Possibility of Twinning

It has crossed our mind that, deep down, Gary Hill longs for his unknown twin. Of course we don't mean this literally, but over the years we have noticed that his fascination with twins pops up here and there[10]. It's almost like a nostalgia for the infamous "semblable"—the precise counterpart without whom one never feels totally "at home." In his projective installations the artist has discovered a structural orientation—an abode of the double—capable of engendering within the viewer a sense of loss for his or her own counterpart, as if the function of art were to awaken a lack. With appropriate attention, such absence opens into the space of the *possible twin*. There is no better paradigm for the structural/functional principle at work in these projective installations than the deep time and deep space of the possibility of twinning. And this is the angelic activity performed by the work through the agency of our direct participation.

The Twin is not a Narcissistic fantasy but a *way beyond* the entrancement of that closed circuitry, integrating the surface clarity of an impersonal "object" with the intimate and revelatory truth of the "subject." *I twin,* so to speak, by a process of conscious alignment. I embrace my "almost me" by way of recognition. The active stance of skewed self-reflection supplants the almost mechanical reproduction of exact reflection.

The work *facing faces* amounts to a "participated alternative" to, a subversive contrary of, what William Blake called "fearful symmetry"—the merely rational order that keeps us imprisoned in the "mind-forged manacles" of one-dimensional reality. The title itself functions as a poem, a species of the poetic that may manifest in what we have named an "axial poem"[11]. Such a poem performs an act of language that causes the reflective mind to "turn on its axis," a sort of poetic *metanoia*[12] capable of jolting awareness into transformation mode. The title/poem can be read in many ways:

"The faces are facing each other." "The act of facing *faces*" [verb, as in "faces the music"]. "Facing *faces* [noun] means we look into faces of real people." The multivalent grammar, or torsional syntax, is "accurate," to paraphrase the poet Wallace Stevens, with respect to the structure of reality *here, in this space*. The actual space right here in front of us has a direct impact on our minds—in a sense, *the space, in its initiatory force, itself becomes our twin*. What empowers this space is the deeper power to *declare context*. And, returning to angelic logic, this power is perhaps the most subversive of all forces. It radically orients and reorients space, time, language, thought, even dreams and visions—simply by declaration.[13] I perform the action by saying it, and it refers only to itself. *Angels. Martin?* This path itself is an open question, leading *out*....

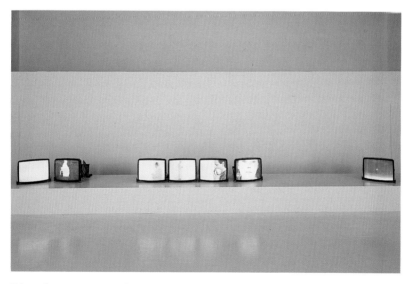

Disturbance (among the jars) (1988)

Notes to *standing* apart / *facing faces*

[1] For both pieces the same person appears: a man, Native American (Sioux/Yakima), "of a certain age," a fisherman temporarily working as a day-laborer in Seattle hired from a street corner. In another context, say, portraiture, we might use the term "model" for a "subject" who is hired by the hour to pose; here, as we shall see, he goes beyond the status of model or subject. He is recorded, in Gary Hill's studio in Seattle, simultaneously by four cameras, two for each piece—full shots of a standing figure for *standing* apart and close-ups of shoulders and head for *facing faces*. The effect is that one figure is looking straight out at you at the same time that the second figure is looking at the first. They then switch positions—the second figure looks you in the eyes as the first figure looks at him. You the viewer stand, so to speak, at the apex of a triangle of shifting views. In *standing* apart, the full figure is viewed standing in projections onto the two walls that meet at the corner, whereas in *facing faces* he is viewed only from the shoulders up on two 20" monitors at something greater than right angles.

For the technically minded, the recording sequence is: first, he stands facing directly at the camera and, after a few minutes, turns his head 45 degrees to his right; second, after a few minutes, he turns back to face the camera. When positioned side-by-side and synchronized (for *facing faces,* video monitors or, for *standing* apart, projections onto walls) the effect is two figures in each piece alternating their stance of looking at the viewer and looking at the other.

[2] In choosing this installation as his contribution to the group show "*Engel, Engel,*" the artist saw the connection with curator Cathrin Pichler's title, but the work had already been created some months before (and exhibited at the Gladstone Gallery), as it were, ready-made for the occasion. This sort of "synchronicity" encourages our fond observance of the many connections "hidden" in the words. "Parataxis" means "order by juxtaposition" (or "syntax by apposition," in the poet Charles Olson's phrase) and relates to the root meaning of "neighborly" as "nigh" or near. In this "neighborhood" of angels we are reminded that "love thy neighbor" means embrace or respond fully to what happens to come your way. We are enjoined to live paratactically, that is, *concretely*; our responsibility is site-specific. Gary Hill's meditations on the principle of

neighborhood/nearness/site-specificity include the installation *Between Cinema and a Hard Place* (1991) (text by Heidegger) and the single-channel video *Site Recite: A Prologue* (1989).

[3]The Greek word *angelos* means "messenger," one who acts as a mediator, brings the news, as it were, across discontinuous planes of being. In our sense the "angelic message" is a herald of possibility—the opening of a possible field of view.

[4]"A *limen* in Latin is a threshold. While its current usage is principally behavioral with respect to the threshold of a physiological or psychological response, in fact, liminal or borderline states are anywhere that something is about to undergo a phase transition or turn into something else. They range from the ordinary to the extraordinary...." For further discussion of liminality as conscious choice to move freely within the emergent, see *Gary Hill: HanD HearD/liminal objects [Gary Hill's Projective Installations, Number 1]* (Note 1).

[5]What is it about this questioning of the status of presence that reminds us of Yogi Berra's famous response to the question "What time is it?": "You mean now?"?

The reflexive character of presence has through "deconstruction" provoked an entire philo-sophical generation's skeptical attitude towards the valorization of presence—a valorization that has pervaded Western metaphysical traditions for millennia. Yet presence, like impermanence, is something that won't go away. We would suggest that there is a dimension of the question that is only now able be explored in thought—a side that links presence to the elusive question of the nature of awareness itself.

[6]As we have mentioned, we intend certain special terms like "distinction" and "performative" to have a range of meanings, some of which are not obvious.

For "distinction," see above "On View," Note 1.

"Performative" is a term invented by the philosopher J.L. Austin to refer to utterances that *literally perform the action of which they speak*: e.g., I promise, I wish, I accuse, I name, etc. — actions performed in the very saying. Our point is that such verbal actions close the gap between word and meaning, but performative utterances can only do their work in the specific contexts that call them forth: *performative language is always site/occasion-specific and concrete*. Obviously we are in the process of extending the term in uses like the one above. For more on both terms

see our "Cut to the Radical of Orientation: Twin Notes on Being in Touch in Gary Hill's [Videosomatic] Installation, Cut Pipe" in Public #13: Touch in Contemporary Art (Toronto: 1996)

[7]In the original showing at the Gladstone Gallery, Gary Hill's *Viewer*—presenting a line of seventeen, video-projected day-workers—was shown in an adjacent room; this man stood apart from these others: a solitary; a man distinct from the collective, from the common, from the generality of men—even from "his own kind.." (Fact: his presence on the corner that morning in Seattle, when Gary Hill passed by, was somewhat unusual; he's a fisherman by trade, and only the pressure of raw financial need would bring him there.) While these seventeen others are not there to be a foil for his uniqueness, his apartness seems absolute, or else subsists in a more internal domain, portending another, more strangely sited commonality.

[8]"*Ein jede Engel ist schrecklich*"—The first *Duino Elegy.* The poet Robert Duncan said that when he was at the point of composing what would become his first major work, *The Opening of the Field,* he received two angelic incursions—something like offers you might not think you could refuse—and he refused. He wasn't up for turning his life and work over to the angel, and the great work that came out of this refusal was the necessary compromise in dealing with the necessary angel.

[9]One might think of Joseph Beuys' encounter with the coyote—or should we say, Coyote!

Further Note (May 1997): We cannot help marking this "art space" with its historical cut into the human: Following the first exhibition of these pieces at the Gladstone Gallery, Gary Hill came to know Martin a bit more. He learned, after being out of the country, that Martin had come to some trouble, ending with his incarceration. The issues are complex and still partially unclear; however, there is no question but that Martin's story belongs to the lore of the legally disadvantaged and under-represented–a story that will want to be told in another context. We simply want to take note of the event and to acknowledge that Gary Hill has gone to extraordinary lengths to assist Martin and indeed has been virtually his only "friend" in a dark time. Gary Hill has enlisted further support for Martin's legal defense, including from the artist's principal gallery (Donald Young) and the New York gallery for this piece (Barbara Gladstone).

[10] The twin is often just behind the scenes in Gary Hill's world: The book by Maurice Blanchot whose title resonates as a near neighbor of *standing* apart is in English *The One Who Was Standing Apart from Me* [Station Hill of Barrytown, Ltd.: Barrytown, 1993 & 1997] (at a remove from the actual French title, *Celui qui ne m'accompagnait pas*) and concerns a "double" or "alter ego" of uncertain status. Blanchot's *Thomas the Obscure* is the core text for Gary Hill's *Incidence of Catastrophe*: Blanchot's Thomas appears related to the "obscure words of the twin" in the Gnostic *Gospel of Thomas*, which figured centrally in the 1988 Pompidou installation, *Disturbance (among the jars)*. For more on "twin," see below "Projection: The Space of Great Happening," Note 6.

[11] Also called "torsional poems," these are terms that George Quasha has used for a kind of poem he writes (in recognition of a fundamental capacity of language for optimal multiplicity) and upon which is based his creation of titles in collaboration with Gary Hill, including *standing apart, facing faces, HanD HearD,* and *liminal objects.* In this connection it should be mentioned that Gary Hill's own writing—his use of language in his works—belongs as much to the world of poetics (and metapoetics) as to video and installation art.

[12] This Greek New Testament term (literally, "change" [meta] of "mind" [noia]) gets translated (via Latin) as "conversion" (literally, "a turning around" of the mind), not incidentally what it comes to mean, a change in belief or ideological allegiance.

[13] This is a somewhat special use of *declare* (used earlier but not glossed till now): To publicly affirm an intuited possibility with the intent of actualizing it in such a way that its virtuality (the reach of possibility) is not lost. What I declare is not simply frozen in static reification; rather, the source of my intuition which has given force to my declaration is lifted into manifestation and becomes an ongoing resource. What now becomes real remains resonant with its root possibility. A declaration is grounded in the recognition of what is intuited to already be the case. The deep space from which the power to declare context comes, we call "paracontextuality"—the radically open context of contexts.

PROJECTION

THE SPACE OF GREAT HAPPENING

If someone asked me, "Where do you take place?," I might answer, "Here, where do you think?" This is not a question that automatically makes sense. I don't necessarily think of myself as an *event*—a "taking place" within an environment. In addition, the question is different in every context. If I'm an actor on a stage, my "eventuality"—my event-reality—is self-evident because spatially and temporally framed. I may witness myself, for a change, somewhat as others do, especially if I'm used to hearing or seeing taped versions of my performance. Likewise if I'm playing tennis, even though I'm hardly watching myself, I am performing within a context that sees me as event and that promises reflection—I will be *replayed* in mind, in recording, in report, in assessment, etc. I am aware of my eventuality by virtue of replayability and reflection. My fear or hope of assessment—I want to win, communicate, look good, etc.—fuels my connection with the frame of the event. I stand within a projection, and take place accordingly.

This account, simple and abstract as it is, suggests that we are art-beings who exist in relation to more or less continuous projection of our own event. What we actually *do* in that projection is open to interpretation from many points of view—psychological, geometrical, aesthetic, ontological…—depending in part upon the declared frame. Sometimes the frame itself is ambiguous or otherwise *open*, in which case the meaning of our happening is also "open"—which can mean anything from *free* and *possible* to *catastrophic* and *mad.* If in such a situation someone asks me "where" I take place, I may no longer say "here" as though it meant something clear.

Imagine that you are entering a long dark hall in which the only light is the measured occurrence of small luminous spots along either side, at about eye-level, on the walls. As you approach, you see that each "spot" is a person in the distance (seated, standing, or reclining), who, in response to your presence, "gets motivated" and walks toward you, then stands in front of you, eye to eye. Here you remain, faced with this other person—"no one special," just her- or himself, like someone in the neighborhood finally coming to meet you face to face. Strangely familiar; yet completely other. It has its own light, this *other,* the only light there, which plays on your surface and the faces of the visitors in the room, like moonlight—a cool and thinly resonant light, a *space* consisting of residual light that seems to call up one's emotions for no reason but that the space is empty. (Emotion is one way nature has of abhorring a vacuum!). And here we are, viewers (*voyeurs/voyageurs*) in this darkly illuminating space with the consistency of water and the tendency to drift and a slow welling up of feeling in waves moving *between us and the projected other*, like ships signaling half-seen, half-known ships. Tall ships.

Surf Faces

Tall Ships. We have been imagining—you might say, projecting—a visit to Gary Hill's 1992 installation bearing a Turneresque name that might make us expect an archaic landscape. What we get is something closer to an archetypal mindscape—like entering a birth canal in reverse, or descending into the Underworld with Ulysses, or dreaming an encounter with ghostly yet vividly *personal* faces. Moving thus in the silent territory of mind, we easily find ourselves replaying the encounters, "re-projecting" them as mental events—as though, once having viewed the Mysteries, we are now initiates and retain the human flavor of these unidentified but unmistakable entities. Dreamy, yes,

but once you have met these beings in the intimate dark, you're not likely to forget them. (How many human circumstances can *that* be said about?) If this is projection, then how does it differ from life itself?

Ambiguously, or, we might say, only liminally. Once we have crossed the threshold of *Tall Ships* we are qualified to observe: Projection goes on all around us and all the time, but most poignantly it leads the way, *it goes before us*. (We are, after all, a race of moviegoers, and we expect nothing less than life writ large on the great luminous space *out there*—sky, screen, (sur)face of the other. And as art-beings, we may even have a certain right to the expectation.) So, obviously we put off as long as possible asking the impossible question,

What is projection?

Quick impossible answer:

Projection is what makes reality surface.
(A dolphin breaching the water.)

It does so by surfacing reality.
(Asphalt or gold leaf, same difference.)[1]

Or, stating it graphically to retain the torque of ambiguity in the problem:

projection is what makes reality

surface

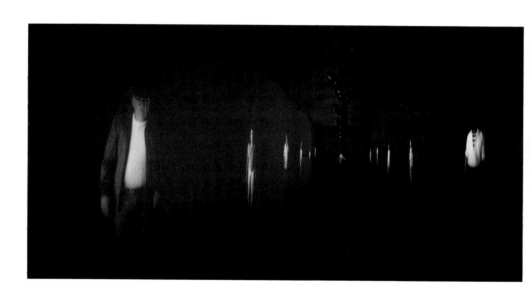

Tall Ships (1992)

Reality on the Line

Is reality what is *cast upon* a surface, as the word "project" (to "throw forth") might suggest? In this case, reality is in the projector (the artist, the film or recording medium, the machine) and the surface is a neutral receiver—the "silver screen."

Or is reality what is brought up—made to disclose itself—from *beneath*, from the unrevealed or unconscious or otherwise unknown? In this case the projector is the *spur*, the instrument of cutting through the surface or boundary that holds back the real, and the artist is the liberator or agent of release[2].

Or is the art-act *liminal to both* of these, the cultivation of the ambi-valent *between*, the medium as middle and the edge of (inter)activity?[3] If this third possibility is so, then in the graphic formulation above, the <u>horizontal line</u> stands for <u>one's presence</u>—the view of the viewer viewing, the (inter)space of the great happening that is the release of what is "normally" held from us. This is the space—the event horizon—where it is possible to know, more simply, and liminally

<div align="center">

reality

surfaces

</div>

As you voyage down that long hall, yourself a tall ship catching the light of the other by which you *orient yourself* in the confusing dark, you take place as the twin of a possible person—the projection that comes toward you, a sort of angelic messenger bringing you news of what you have unconsciously cast before you.

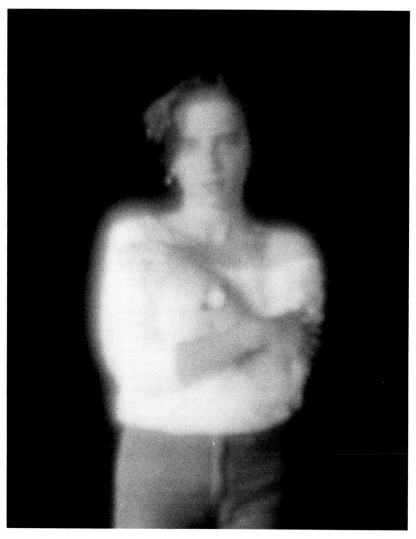

Tall Ships DETAIL (1992)

> *Je est un autre.*
>
> ARTHUR RIMBAUD

> **It seems to me I take place** out there.
>
> ROBERT DUNCAN[4]

Projection, a Word

To think or say this word is to participate in a confusion, at least potentially. It stands for something the mind does–*we ourselves do*–pretty much all the time. It also stands for the mechanism and medium, psychological or physical, that implements it. Perhaps such a crossing of domains accounts in part for the immense power that artistic projection has for us. Projection as metaphor and means has had a unique appeal from Plato's cave to *camera oscura,* Proust's Magic Lantern, the silver screen, holograms and video installation. Its attraction as a possible domain seems to combine what somehow belongs to us with what is utterly other and out there.

When a video projector casts the image of a person on a wall, we are never unaware that we are viewing a projection. Yet in works like *Tall Ships, Viewer,* and *standing* apart the person is also experienced as *real*, even somehow as *more real* than a person standing nearby. For a moment the projection co-opts the space of the real. Undeniably there is a special intensity that intentional projection invites, obviously lacking in our casual interaction with people. *Tall Ships* extends this truth by provoking an encounter so curiously real (although the figures appear in black and white and not very finely focused) that some viewers find themselves involuntarily responding as though a stranger had walked right up to them. The projection is charged by its *resemblance* to the real, its

momentary confusion with the real, especially when the real does something we try to keep it from doing–confronting us face to face. In *Viewer* too there is an uncomfortable intensity, of something a bit too real, as seventeen waiting (all male) day-workers stare at us as we pass, their eyes following us everywhere and their lives, their *wanting*, pressing against us. It's as though they were projecting back at us.

Perhaps all of these projection-works by Gary Hill—especially *Tall Ships* due to its effective "interactive" mechanism—demonstrate the instant "feedback" quality of intensive projectivity. It's as though the projection draws you out into a kind of identification with the other, only to come back at you with its difference—or rather *your* difference. But difference from what? Not, surely, just one's difference from the other, which, on the face of it, is hardly news. No, what the feedback brings us is, as it were, *our difference from ourselves.* And that's *poetic* news (to paraphrase Ezra Pound)—"news that stays news." To be learning of one's difference from the "oneself" that one thinks one knows, is new every second of the way. So it is that the feedback is a mirroring, but a mirror that reflects truth which, without reflection, is hard to see. *Poetic?* Yes, but only in the root (the true) sense of something *made,* a created truth. This is the work *on* oneself that is also work *out of* oneself as the art-being responsible for the projection. I may be a mere viewer gazing upon the *artist's* projection, but if it *gets* me, bounces me back to the *instantly present reality of myself,* then I begin to wake up to *my* role as projector of the projection of the other. I'm a shared reality, co-holder of a space of great happening that is shared otherness and participated difference.

Twins, Twines, Torques and Folds

Of course this sounds like double-talk, and for good reason. To speak accurately about *projection,* in the fullness of its interactivity between viewer and viewed, is to harness the *twinning force* of language. This is the energy of doubling—of which a palpable embodiment is *standing* apart, wherein the "same" person witnesses himself (and we witness him witnessing himself witnessing us, etc.). To be sure, there's something eerie about such "twinning," but what is it, after all, that's uncanny about twins? "Identical" twins are distinct human beings who seem to do an impossible thing—share an identity. Here the very difference between "the different" and "the same" becomes confounded. The "con*fusion*" is literally the case: each takes his identity from the other. Twins often experience heightened intersubjectivity under quite ordinary circumstances—a projection/counter-projection—and this may explain why the metaphor of "twin" and "twinning" is so enormously attractive in certain kinds of art. There's more than etymology at stake in the connection between *twin* and *twine* (intertwine) and the vine-like *torsional force* behind the double-talk inspired by projection.

We are noticing that the phenomenology of projection has a parallel dimension in ambi-valent (torsional) language—words and syntax with an apparent double meaning, as though a verbal event turns on its axis and shifts its semantic force. Gary Hill's language—in his own prose statements, his use of verbal and textual material in his work, and in his titles—belongs to the world of poetry. Likewise the images and narrative structures throughout his work (beginning in his single-channel videos) belong to this poetic domain. Poetry we define as "conscious speaking with listening" in the way it seems to turn around inside the speaker/listener's ear.[5] His title for the collected

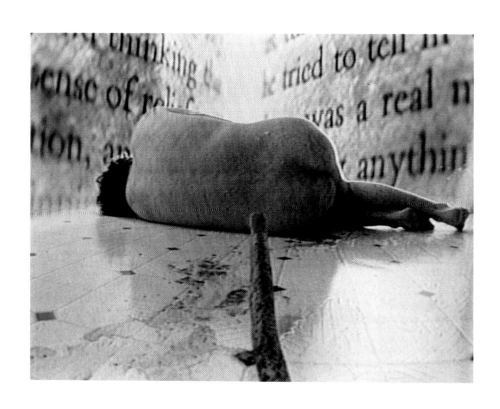

Incidence of Catastrophe (1987-88)

And Sat Down Beside Her (1990)

single-channel work, *Spinning the Spur of the Moment*, combines the notion of torsional force with that of penetrating and awakening intervention concentrated in an instant of time. The implication is that a *projective act*—whether verbal, imagistic or narrative—disrupts the plane of perceived reality by introducing a "fold" in the place of the normal distinction "subject" and "object."

Consider in this regard both the title and the tortuous narrative of the single-channel video *Incidence of Catastrophe* (1987-88, 43:51 minutes), which, in the way it uses material from Maurice Blanchot's fiction *Thomas the Obscure,* creates a sort of "double" of the mysterious French text—a topologically catastrophic rendering of a text as the site of creative/de-creative self-interferrence[6]. This work, in which the camera veritably ravishes the printed page with acts of reading and brilliantly lit page-handling, prefigures the later installation work involving projection of, and onto, text. *And Sat Down Beside Her* (1990)[7] and *I Believe It Is an Image in Light of the Other* (1991-92)[8]. In these installations (in which one walks around illuminated objects, sensualized surfaces, readable things, imagized texts…) it's as though the viewer entered directly into the world of *Incidence…*[9]—oneself as the angle (view) of incidence or projective force—whose incursion into the still (and moving) life of *the gathering of things* creates …*Catastrophe*, that is, utterly particular meaning folded into the surface of the world. A re-projection of the world as *lived space,* sat down beside.

.

I Believe It Is an Image in Light of the Other (1991-92)

ent. What calm next to yo
emed to me we were si
s in through the little wind
that penetrates everywhe
and is the brightness of th
troom well, a room whose b
ctly, with your characteristic r
n't leave, because it is already dom
low exact everything is, more ex
be. You are acquainted with shadows. Ho
he darkness of the night should be this m
brightness. I could describe to you the
orm, perhaps without knowing it, and
, I se hallway lit by the flar; if I
ady m ps come to me e, Bu
l these ander ut, t
obey r of th wh
ome d go
sion
? Tow

I Believe It Is an Image in Light of the Other (1991-92)

Parataxis

The juxtaposition of phrases without the use of logical connectives (site-specific language)—is especially common in the oral story-telling mode of laying out incidents with no logic but that they're *there*. The paratactic mode expresses the arrangement of *events* as though they were *things*. In these projective installations involving a display of (illuminated) objects, things seem to talk back, as though they were events, at least potentially. The site recites, to borrow the title of Gary Hill's next-to-the-last single-channel videotape—*Site Recite (A Prologue)* (1989; 4:05 mins.). The space speaks, like a voice from beyond the grave [voice over], through things and the "little deaths that pile up": bones, butterfly wings, egg shells, seed pods, crumpled notes, skulls—things acting like words uttered in quick views. Likewise in *Inasmuch As It Is Always Already Taking Place* (1990) the parts speak—body parts, one body with many voices, the multiple personality that any*body* inevitably *is* through the multiplicity of one's self-projections. (Isn't personal self-projection really site-specific?)

Here in *Inasmuch…* the "projection" implicates a deeper fact about surface-viewing than the literal one that video or film projects onto a surface. The piece consists of a sixteen-channel video/sound installation comprising half-inch to twenty-three-inch black-and-white TV tubes. These are positioned in a horizontal wall inset, somewhat below eye level—an in*jection*, an in*spuration*, a con*cave* "project." The body, dismembered like Osiris[10], livingly and breathingly displays itself, a *nature vivante* of actually life-sized parts. The fragmented body projects a *possible body*, body as *field,* as murmuring self-textualizing space, a body knowable as the mind knows itself. *Body as projection of mind*, thanks to "art-being's" long lineage from Osirean myth to Cubistic painting, is not

limited to any specific logic but can imagine possible wholenesses, and so enjoys the permission to lie about as it likes. And say what it wants (lacks).

Inasmuch As It Is Already Taking Place (1990)

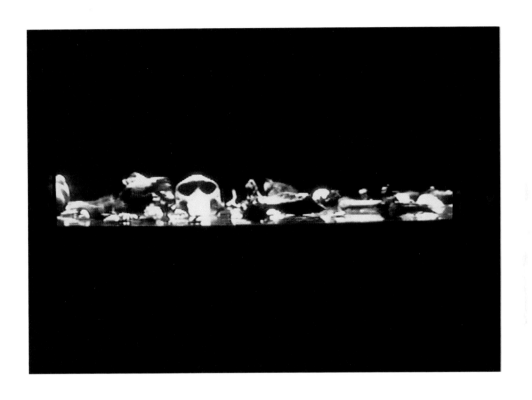

Site Recite (a prologue) (1989)

> What kind of syntax/synapse serves
> an open field in-
> vaginating toward a
> possible center?

ONTONONYMOUS THE PARTICULAR

The Axis

From single channel (one birth canal) to multiple channels (confluence of twinning possibilities), Gary Hill's work evolves structurally and technically toward open projectivity and awareness by field. In the four-channel installation *Clover* (1994), the voyager, a "viewer" in the woods, is seen from behind. The camera is attached to his back and shows head and shoulders against the "background" of "oncoming trees." He walks away from "us," the "viewers," toward an unknown point *out there*. The background is the *in*ground into which *viewing* makes its incursion, a continuous conscious projection *through* the video tube *into* a world that (like the actual meeting point in *Tall Ships*) never arrives.[11] Or four worlds, as we see in our circumambulation of the four twenty-inch monitors, each displaying a different man walking out into the approaching woods. ... Journeying around the mandala-like construction, as though performing our own slow round-dance, we re-project the four paths/leaves of clover pointing inward toward an unknown center, the life or source, which at the same time travel outward, themselves projecting toward an open end. The syntax is axial: Antithetical (dialogical?) and (im)possible trajectories pursue their twin destinations:

here
at the crossroads,
there
in the missing middle....

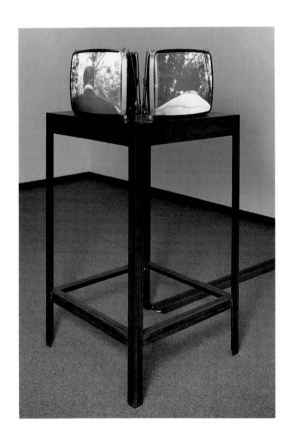

Clover (1994)

Notes to "Projection"

[1] The verb "surface" is multivalent: "to surface" means (1) [intransitive] To rise to the surface; to emerge after concealment: *the diver surfaces*; (2) [transitive] To apply a surface to: *surface a road (with asphalt)*. In the two graphic formulations that follow, the word "surface[s]" below the horizontal line can also be read as a noun.

[2] Gary Hill named his three volume laserdisc of collected single-channel video works, *Spinning the Spur of the Moment* (Voyager, 1994). Interestingly he had considered giving the installation *Viewer* the name "*Cast,*" which would have the double meaning of "project (= throw forth)" and "a surface impression formed in a mold."

[3] See above Note 4 on "limen" in "standing *apart*/facing faces." What is conceptually difficult in observing liminal states is that even fundamental distinctions like *space* and *time* come into question. *Where* are we and *when* are we in the in-between? In what sense is what we observe "really there"? Or is it only *liminally there?*

[4] Rimbaud (1854-1891) in his famous visionary letter to his teacher says, "I is an other." The American poet Robert Duncan (1919-1988) made the quoted remark in a lecture, probably in the '60s.

[5] The link between Gary Hill's work and the world of innovative poetry is a matter of historical fact which the artist has discussed many times and which we, in our nearly two decades of collaborating with him, have experienced firsthand. While he has not been particularly influenced by the poet Charles Olson (1910-1970), the latter's works and ideas have reached him indirectly. We intend at a later time to explore the connection between video projection and Olson's influential notion of "Projective Verse" (1950) (most available in *The Selected Writings of Charles Olson*, ed. by Robert Creeley [New Directions: New York, 1966]).

[6] Gary Hill used the Robert Lamberton translation of Blanchot's *Thomas l'Obscur* originally published by David Lewis, Inc. (New York: 1973) and subsequently by Station Hill Press: Barrytown, New York, 1988 (original French edition, Gallimard: Paris, France, 1941.) *Thomas the Obscure* has a "twin" text in the Gnostic *Gospel of Thomas*; Gary Hill used material from the latter, itself rich in

"twin" symbolism, in the 7-channel installation, *Disturbance (among the jars)* (Paris: 1988, in collaboration with George Quasha). See above Note 10 to "standing *apart*/facing faces." Also see George Quasha's "Disturbing Unnarative of the Perplexed Parapraxis (A Twin Text for *Disturbance*)," in *Gary Hill: Disturbance (among the jars)*, catalogue, Musée d'Art Moderne, Villeneuve d'Ascq, France: 1989.

[7] Three-part mixed media installation with content derived in part from *Thomas the Obscure* by Maurice Blanchot in which the narrator imagines he sees a woman in the form of a spider. Gary Hill creates sculptural analogies to the form of arachnids, and, in one part, a video image of his own face is projected onto an open book set upon a chair.

[8] Seven-channel video/sound installation, with seven hanging 4-inch black-and-white video displays and a projection element consisting of seven modified video monitors and projection lenses placed inside seven black metal cylinders which hang from the ceiling. The only source of light in the darkened room is from the images of different parts of a male body, and a chair, projected onto open books lying on the floor. The texts illuminated by the images are excerpts from a Blanchot fiction, *The Last Man*, in the Lydia Davis English translation (Columbia University Press, New York).

[9] "Incidence" is multivalent: (1) happening; (2) frequency of occurrence; (3) the incursion of a projectile [spur] or radiation on a surface; (4) angle of incidence. [In the projective installation *Remarks on Colors* (1994; 45 mins.) the young girl, reading in real-time Wittgenstein's text of that name, pronounces "angles," "angels"—angel of incidence or incidence of angels? To paraphrase Rilke, *any angel is catastrophic*.] "Catastrophe" is used most importantly in its topological sense of a discontinuity in a process that gives rise to an unanticipated circumstance or form.

[10] The ancient Egyptian god whose annual death and resurrection personified the self-renewing vitality and fertility of nature: murdered by his brother, Set, and dismembered into fourteen parts, his body was spread across Egypt, eventually to be regathered by Isis.

[11] The sense of suspension—cf. the four-channel installation with thirty monitors, *Suspension of Disbelief (for Marine)* (1991-1992)—is never far from the center of the process in Gary Hill's

work: the labyrinthine journey (*Withershins,* 1996); the state of "still point" in riding the perpetual wave (*Learning Curve [Still Point],* 1993); the endless cycling of self-dividing/self-reversing and indeterminate image accumulation (*Circular Breathing,* 1994), etc. At issue here: the *retention* of energy, memory and awareness, a holding in the middle of the process, and the discovery of alternative modes of *focus.* Such is "the space of great happening" in the oscillation of projection/counter-projection.

Remarks on Color (1994)

Gary Hill biography

SELECTED SOLO EXHIBITIONS

1997

Westfälisches Landesmuseum, Münster, Germany

1996

Galleria Lia Rumma, Naples, Italy

Galerie des Archives, Paris, France

Donald Young Gallery, Seattle, Washington

Barbara Gladstone Gallery, New York, New York

White Cube, London, England

"Gary Hill: *Withershins*," Institute of Contemporary Art, Philadelphia, Pennsylvania

Kunst- und Ausstellungshalle der Bundesrepublik Deutschland, (Forum), Bonn, Germany

1995

"Gary Hill," Moderna Museet, Stockholm, Sweden (Scandinavian touring exhibition organized in collaboration with Riksutställningar, Stockholm, Sweden)

1994-95

"Gary Hill," (travelling exhibition organized by Henry Art Gallery, Seattle, Washington). Travelled to: Hirshhorn Museum and Sculpture Garden, Washington D.C.; Henry Art Gallery, Seattle, Washington; Museum of Contemporary Art, Chicago, Illinois; Museum of Contemporary Art, Los Angeles, California; Guggenheim Museum SoHo, New York, New York; Kemper Museum of Contemporary Art and Design, Kansas City, Missouri

1994

"Gary Hill," Musée d'Art Contemporain, Lyon, France

"Imagining the Brain Closer than the Eyes," Museum für Gegenwartskunst, Öffentliche Kunstsammlung, Basel, Switzerland

1993

"Gary Hill: Sites Recited," Long Beach Museum of Art, Long Beach, California

"Gary Hill: In Light of the Other," Museum of Modern Art, Oxford, England (organized in collaboration with the Tate Gallery Liverpool)

"Gary Hill," Donald Young Gallery, Seattle, Washington

1992-93

"Gary Hill," (travelling exhibition organized by the Centre Georges Pompidou, Paris, France). Travelled to: Musée National d'Art Moderne, Centre Georges Pompidou, Paris, France; IVAM Centre Julio Gonzalez, Valencia, Spain; Stedelijk Museum, Amsterdam, The

Netherlands; Künsthalle, Vienna, Austria

1992
Stedelijk Van Abbemuseum, Eindhoven, The Netherlands

"Gary Hill," Le Creux de L'Enfer, Centre d'Art Contemporain, Thiers, France

"I Believe It Is an Image," Watari Museum of Contemporary Art, Tokyo, Japan

1991
Galerie des Archives, Paris, France

Nykytaiteen Museo: The Museum of Contemporary Art, Helsinki, Finland (retrospective of videotapes)

1990
Galerie des Archives, Paris, France

Galerie Huset/Ny Carlsberg Glyptotek Museum, Copenhagen, Denmark

Museum of Modern Art, New York, New York

1989
Kijkuis, The Hague, The Netherlands

Musée d'Art Moderne, Villeneuve d'Ascq, France

1988
Western Front, Vancouver, B.C., Canada (screening)

Espace lyonnais d'art contemporain (ELAC), Lyon, France (retrospective screening of videotapes)

1987
Museum of Contemporary Art, Los Angeles, California

2nd Seminar on International Video, St. Gervais-Genève, Geneva, Switzerland (retrospective screening of videotapes)

1986
Whitney Museum of American Art, New York, New York (retrospective screening of videotapes)

1983
International Cultural Center, Antwerp, Belgium (screening)

The American Center, Paris, France (retrospective screening of videotapes)

Whitney Museum of American Art, New York, New York

Monte Video, Amsterdam, The Netherlands (screening)

1982
Galerie H at OregonF, Steirischer Herbst, Graz, Austria

Long Beach Museum of Art, Long Beach, California

1981
The Kitchen Center for Music, Video and Dance, New York, New York

And/Or Gallery, Seattle, Washington

1980
Media Study, Buffalo, New York

"Video Viewpoints," Museum of Modern Art, New York, New York (screening)

1979
The Kitchen Center for Music, Video and Dance, New York, New York

Everson Museum, Syracuse, New York

1976
Anthology Film Archives,
New York, New York
(screening)

1974
South Houston Gallery,
New York, New York

1973
Woodstock Artists' Association, Woodstock, New York

1971
Polaris Gallery, Woodstock,
New York

SELECTED GROUP EXHIBITIONS

1997
"Angel, Angel," Kunsthalle
Wien, Austria

"The Twentieth Century:
The Age of Modern Art,"
Martin Gropius Bau, Berlin,
Germany; travelled to: Royal
Academy of Arts, London,
England

1996-97
"Being and Time: The Emergence of Video Projection,"
(travelling exhibition organized by the Albright-Knox
Art Gallery, Buffalo, New
York). Travelled to:
Cranbrook Art Museum,
Bloomfield Hills, Michigan;
Portland Art Museum, Portland, Oregon; Contemporary Arts Museum, Houston,
Texas

Hamburger Bahnhof-
Museum für Gegenwart,
Berlin, Germany

"The Red Gate," Museum
Van Hedendaagse Kunst
Gent, Belgium

1995
"ARS '95 Helsinki," The
Finnish National Gallery,
Helsinki, Finland

"Identità e Alterità," Venice
Biennale, Venice, Italy

Carnegie International,
Carnegie Museum of Art,
Pittsburgh, Pennsylvania

Biennale d'Art Contemporain,
Lyon, France

1994
"Múltiplas Dimensões,"
Centro Cultural de Belém,
Lisbon, Portugal

"Cocido y Crudo," Centro de
Arte Reina Sofia, Madrid,
Spain

São Paulo Bienal, São Paulo,
Brazil

"Facts and Figures," Lannan
Foundation, Los Angeles,
California

1993
"American Art in the 20th
Century, Painting and Sculpture 1913-1993," Royal
Academy, London, England;
Martin -Gropius Bau, Berlin,
Germany

"Eadweard Muybridge, Bill
Viola, Giulio Paolini, Gary
Hill, James Coleman,"
Ydessa Hendeles Art Foundation, Toronto, Ontario,
Canada

"Passageworks," Rooseum,
Malmö, Sweden

"The 21st Century,"
Künsthalle Basel, Basel,
Switzerland

"Biennial Exhibition,"
Whitney Museum of American Art, New York, New York

1992

"Performing Objects," Institute of Contemporary Art, Boston, Massachusetts

"Metamorphose," St. Gervais-Genève, Geneva, Switzerland

"Manifest," Musée national d'art moderne, Centre Georges Pompidou, Paris, France

"Art at the Armory: Occupied Territory," Museum of Contemporary Art, Chicago, Illinois

"The Binary Era: New Interactions," Musée d'Ixelles, Brussels, Belgium

"Documenta IX," Museum Fridericianum, Kassel, Germany

"Doubletake: Collective Memory & Current Art," Hayward Gallery, London, England

Donald Young Gallery, Seattle, Washington

1990-92

"Passages de l'image," Musée national d'art moderne, Centre Georges Pompidou, Paris, France (travelling exhibition organized by the Centre Georges Pompidou, Paris, France) Travelled to: Fundacio "la Caixa," Barcelona, Spain; Wexner Art Center, Columbus, Ohio; San Francisco Museum of Modern Art, San Francisco, California

1991

"Biennial Exhibition," Whitney Museum of American Art, New York, New York

"Metropolis," Martin-Gropius-Bau, Berlin, Germany

"Topographie 2: Untergrund," Wiener Festwochen, Vienna, Austria

"Artec '91" International Biennale, Nagoya, Japan

1990

"Tendances multiples (Videos des Annees 80)," Musée national d'art moderne, Centre Georges Pompidou, Paris, France

"Energieen," Stedelijk Museum, Amsterdam, The Netherlands
"Bienal de la Imagen en Movimiento '90," Centro de Arte Reina Sofia, Madrid, Spain

1989

"Video-Skulptur Retrospektiv und Aktuell 1963-1989," Kolnischer Künstverein, Cologne, Germany (travelled to Berlin and Zürich)

"Video and Language," Museum of Modern Art, New York, New York

"Delicate Technology, 2nd Japan Video Television Festival," Spiral Hall, Tokyo, Japan

"Les Cent Jours d'Art Contemporain," Centre International d'Art Contemporain de Montreal, Montreal, Quebec, Canada

"Eye for I: Video Self-Portraits," Whitney Museum of American Art, New York, New York

1988

"As Told To: Structures for Conversation," Walter Philips Gallery, Banff, Alberta, Canada

1987

"Documenta VIII," Museum Fridericianum, Kassel, Germany

"Contemporary Diptychs: Divided Visions," Whitney Museum of American Art, New York, New York

"The Situated Image," Mandeville Gallery, University of California at San Diego (UCSD), La Jolla, California

"The Arts for Television," international travelling exhibition organized by the Museum of Contemporary Art, Los Angeles, California, and the Stedelijk Museum, Amsterdam, The Netherlands

"Cinq Pièces Avec Vue," Centre Génevois de Gravure Contemporaine, Geneva, Switzerland

"Japan 87 Video Television Festival," Tokyo, Japan

1986

"Video: Recent Aquisitions," Museum of Modern Art, New York, New York

"Video and Language/Video as Language," Los Angeles Contemporary Exhibitions (LACE), Los Angeles, California

"Resolution: A Critique of Video Art," Los Angeles Contemporary Exhibitions (LACE), Los Angeles, California

"Collections Videos— Acquisitions Depuis 1977," Musée National d'art Moderne, Centre Georges Pompidou, Paris, France

"II National Video Festival of Madrid," Circulo de Bellas Artes, Madrid, Spain

"Poetic License," Long Beach Museum of Art, Long Beach, California

1985

"Biennial Exhibition," Whitney Museum of American Art, New York New York

"Image/Word: The Art of Reading," New Langton Arts, San Francisco, California

1984

"Biennale di Venezia," Venice, Italy

"So There, Orwell 1984," The Louisiana World Exhibition, New Orleans, Louisiana

"Video: A Retrospective," Long Beach Museum of Art, Long Beach, California

1983

"Art Video Retrospectives et Perspectives," Palais des Beaux-Arts, Brussels, Belgium

"Video As Attitude," University Art Museum, University of New Mexico, Albuquerque, New Mexico

"The Second Link: Viewpoints on Video in the Eighties," Walter Philips Gallery, Banff, Alberta, Canada

"1983 Biennial Exhibition," Whitney Museum of American Art, New York, New York

1982

"The Sydney Biennale," Sydney, Australia

"Gary Hill: Equal Time," Long Beach Museum of Art, Long Beach, California

1981

"Projects Video XXXV," Museum of Modern Art, New York, New York

"New York Video," Stadtische Galerie im Lenbachhaus, Munich, Germany

1979

"Projects Video XXVII," Museum of Modern Art, New York, New York

"Video Revue," Everson Museum of Art, Syracuse, New York

"Beau Fleuve," Media Study, Buffalo, New York (travelled to: The Center for Media Art, American Center in Paris, France; L'espace lyonnais d'action culturelle, Lyon, France; Musée Cantini, Marseille, France)

1977

"New Work in Abstract Video Imagery," Everson Museum of Art, Syracuse, New York

1975

"Projects Video VI," Museum of Modern Art, New York, New York

"Annual Avant-Garde Festival of New York," New York, New York

1974

"Artists from Upstate New York," 55 Mercer Gallery, New York, New York

SELECTED PERFORMANCES

1997

"Splayed Mind Out" (work-in-progress) Gary Hill and Meg Stuart at the Kaaitheater, Brussels, April 23-26

1996

"Mysterious Object" Gary Hill, George Quasha and Charles Stein with Chie Hasegawa and Susan Quasha at the Rhinebeck Performing Arts Center

1993

Gary Hill, George Quasha, Charles Stein and Joan Jonas (on the ocassion of the opening of "Sites Recited" at the Long beach Museum of Art)

"Madness of the Day" Gary Hill with George Quasha and Charles Stein for

"Gary Hill: Day Seminar," on November 7, 1993 at the University of Oxford in Oxford, England in conjunction with the exhibition entitled *Gary Hill: In Light of the Other*

1988

"Soundings" Video Wochen, Basel, Switzerland

1978

"Sums & Differences", Arnolfini Arts Center, Rhinebeck, New York

1972

"Electronic Music: Improvisations," (performance with Jean-Yves Labat), Woodstock Artists' Association, Woodstock, New York

Writings by the Artist

(arranged chronologically)

Primarily Speaking, 1981-83 (New York: Whitney Museum of American Art, 1983).

"Happenstance (explaining it to death)." *Video d'Artistes* (Geneva: Bel Vedere, 1986).

"URA ARU: The Acoustic Palindrome." *Video Guide* 7 (No. 4, 1986).

"Processual Video" (videotape transcription). *2nd International Week of Video* (Geneva: St. Gervais, 1987).

"Primarily Speaking." *Video Communications*, No. 48 (Paris: 1988).

"And if the Right Hand Did not Know What the Left Hand is Doing." *Illuminating Video*, eds. Doug Hall and Sally Jo Fifer (New York: Aperture Press in association with the Bay Area Video Coalition, 1990), pp. 91-99.

"*BEACON* (Two Versions of the Imaginary)," essay from the exhibition catalogue, *ENERGIEEN* (Amsterdam: Stedelijk Museum, 1990). Reprinted in the catalogue, *Bienal de la Imagen en Movimiento '90* (Madrid: Museo Nacional Centro de Arte Reina Sofia, 1990).

"Site Re:cite" from "Unspeakable Images." *Camera Obscura* No. 24, (San Francisco: 1991).

"LEAVES." *Gary Hill—I Believe It Is an Image* (Tokyo: Watari Museum of Contemporary Art, 1992).

"Entre-vue." *Gary Hill* (Paris: Centre Georges Pompidou, 1992), pp. 8-13. Also available in Spanish with an English translation as "Entre-vista" in the exhibition catalogue of the same name (Valencia: IVAM, 1993), pp. 12-17; and in English with Dutch and German translations, as "Inter-view" in the exhibition catalogue of the same name (Amsterdam: Stedelijk Museum and Vienna: Kunsthalle, Wien, 1993), pp. 13-17.

"Entre 1 & 0." *Gary Hill* (Paris: Centre Georges Pompidou, 1992), pp. 74-76. Also available in Spanish with an English translation as "Entre 1 & 0" in the exhibition catalogue of the same name (Valencia: IVAM, 1993), pp. 78-80; and in English with Dutch and German translations, as "Between 1 & 0" in the exhibition catalogue of the same name (Amsterdam: Stedelijk Museum and Vienna: Kunsthalle, Wien, 1993), pp. 37-39.

Principal Books, Catalogues and Monographs

(arranged chronologically)

Quasha, George. "Notes on the Feedback Horizon." *Glass Onion* (Barrytown, N.Y.: Station Hill Press, 1980).

Devriendt, Christine. *L'Oeuvre Video de Gary Hill* (French and English). (Rennes: Université de Rennes II, 1990-91).

Gilbert, Christophe. *Maurice Blanchot/Gary Hill: d'une Ecriture l'Autre (et Son Double)*. (Paris: DEA Université Paris-III, 1992).

Sarrazin, Stephen. *Chimaera Monographe No. 10 (Gary Hill)*. (Montbéliard: Centre International de Création Vidéo Montbéliard, Belfort, 1992).

OTHERWORDSANDIMAGES: Video by Gary Hill (Danish and English). (Copenhagen: Video Gallerie/ Ny Carlsberg Glyptotek, 1990).

Lageira, Jacinto. "Sprachen Video." *Between Cinema and a Hard Place* (French). (Paris: OCO Espace d'Art Contemporain, 1991).

Gary Hill, Video Installations (Eindhoven: Stedelijk Van Abbemuseum, 1992).

Gary Hill—I Believe It Is an Image (Tokyo: Watari Museum of Contemporary Art, 1992).

Gary Hill: Sites Recited, 60 minute videeotape produced, directed and edited for the Long Beach Museum of Art by Carole Ann Klonarides, Media Arts Curator, with Joe Leonardi, General Manager of the LBMA Video Annex, in collaboration with Gary Hill, George Quasha, and Charles Stein (in performance and on-site dialogue), as a video catalogue for *Gary Hill: Sites Recited* at the Long Beach Museum of Art (Dec.3, 1993—Feb. 20, 1994).

Gary Hill (Seattle: Henry Art Gallery, 1994).

Gary Hill: Tall Ships, Clover (Stockholm: Riksutställningar, 1995).

Gary Hill: Imagining the Brain Closer than the Eyes. (Basel: Museum für Gegenwartskunst, 1995). Published in English and in German.

Quasha, George and Charles Stein. *Gary Hill: Hand Heard—Liminal Objects* (Paris and Barrytown, New York: Galerie des Archives and Station Hill Arts of Barrytown, Ltd., 1996).

Principal Texts

(arranged alphabetically)

Cooke, Lynne. "Gary Hill: 'Who am I but a figure of speech?'" *Parkett*, No. 34 (1992), pp. 16-27.

Cooke, Lynne. "Gary Hill: au-dela de Babel." *Gary Hill* (Paris: Centre Georges Pompidou, 1992), pp. 78-115. Also available in Spanish with an English translation as "Gary Hill: mas alla de Babel" in the exhibition catalogue of the same name (Valencia: IVAM, 1993), pp. 82-119; and in English with Dutch and German translations as "Gary Hill: Beyond Babel" in the exhibition catalogue of the same name (Amsterdam: Stedelijk Museum and Vienna: Kunsthalle, Wien), pp. 40-99.

Bellour, Raymond. "Le dernier homme en croix." *2nd Semaine International de Video* (Geneva: Bel Veder, Centre Génevois de Gravure Contemporaine, 1987). Also published in *Illuminating Video*, eds. Doug Hall, Sally Jo Fifer (New York: Aperture Press in association with the Bay Area Video Coalition, 1990), pp. 425-426, and in *OTHERWORDSANDIMAGES: Video by Gary Hill* (Danish and English). (Copenhagen: Video Gallerie/Ny Carlsberg Glyptotek, 1990), pp. 20-26.

Derrida, Jacques. "Videor." *Passages de l'Image* (French). (Paris: Musée National d'Art Moderne, Centre Georges Pompidou, 1990), pp. 158-161. Also available in English in the exhibition catalogue of the same name (Barcelona: Centre Cultural de la Fundacio Caixa de Pensions, 1991), pp. 174-179.

Diserens, Corinne. "Inasmuch As It Is Always Already Taking Place." *Gary Hill: In Light of the Other* (Oxford: The Museum of Modern Art Oxford and Liverpool: Tate Gallery Liverpool, 1993).

Duncan, Michael. "In Plato's Electronic Cave." *Art in America*, Vol 83, no. 6 (June 1995): 68-73.

Fargier, Jean-Paul. "Magie Blanche." *Gary Hill: DISTURBANCE (among the jars)*. (French and English.) (Villeneuve d'Ascq: Musée d'Art Moderne, 1988), unpaginated.

Furlong, Lucinda. "A Manner of Speaking: An Interview with Gary Hill." *Afterimage* 10 (March 1983), pp. 9-16.

Grout, Catherine. "Gary Hill—La condition humaine de la pensee." *Arte Factum*, No. 48 (June/July/August 1993), pp. 8-12.

Huici, Fernando. "Gary Hill: *Beacon*." *Bienal de la Imagen en Movimiento '90* (Madrid: Museo Nacional Centro de Arte Reina Sofia, 1990).

Kain, Jackie. "L'intime du mot: l'oevre video de Gary Hill." *2nd Semaine Internationale de Video* (Geneva: Bel Veder, Centre Génevois de Gravure Contemporaine, 1987).

Kandel, Susan. "Gary Hill, Museum of Contemporary Art," *ArtForum*, Vol. 33, no. 8 (April 1995): 86-7.

Kolpan, Steven. "Bateson: Through the Looking Glass." *Video and the Arts* (Winter 1986), pp. 20, 22, 35, 56. also: *1986 Saw Gallery International Festival of Video Art* (Ottawa, Ontario: Saw Gallery, 1986).

Lageira, Jacinto. "L'image du monde dans le corps du texte." *Gary Hill* (Paris: Centre Georges Pompidou, 1992), pp. 34-71. Also available in Spanish with an English translation as "La imagen del mundo en el cuerpo del texto" in the exhibition catalogue of the same name (Valencia: IVAM, 1993), pp. 38-75.

Lageira, Jacinto. "Une Verbalisation du Regard." *Parachute*, No. 62 (April/May/June 1991), pp. 4-11.

Lestocart, Louis-José. "Gary Hill: Surfer sur le medium / Surfing the Medium," *artpress* (February 1996): pp. 20-27.

Massardier, Hippolyte. "Du bec et des ongles." *Gary Hill* (Paris: Centre Georges Pompidou, 1992), pp. 118-129. Also available in Spanish with an English translation as "Con unas y dientes" in the exhibition catalogue of the same name (Valencia: IVAM, 1993), pp. 120-133.

Mayer, Marc. *Being and Time: The Emergence of Video Projection* (Buffalo: Albright-Knox Art Gallery, 1996).

Mittenthal, Robert. "Standing Still On the Lip of Being: Gary Hill's 'Learning Curve'." *Gary Hill: In Light of the Other* (Oxford: The Museum of Modern Art Oxford and Liverpool: Tate Gallery Liverpool, 1993).

Mittenthal, Robert. "Reading the Unknown: Reaching Gary Hill's *And Sat Down Beside Her*" in *Gary Hill* (Paris: Galerie des Archives, 1990).

Quasha, George (with Charles Stein). "Tall Acts of Seeing." *Gary Hill*, in English with Dutch and German translations, (Amsterdam: Stedelijk Museum and Vienna: Kunsthalle, Wien, 1993), pp. 99-109.

Quasha, George. "Disturbing Unnarrative of the Perplexed Parapraxis (A Twin Text for DISTURBANCE)." *Gary Hill: DISTURBANCE (among the jars)* (French and English). (Villeneuve d'Ascq: Musée d'Art Moderne, 1988), unpaginated.

Quasha, George (with Charles Stein). "A Transpective View." *Spinning the Spur of the Moment (A Retrospective in Three Laserdisc Volumes)*, accompanying catalogue (New York: The Voyager Company, 1994), pp. 4-7.

Quasha, George and Charles Stein. "Cut to the Radical of Orientation: TWIN NOTES ON being in touch in Gary Hill's [Videosomatic] Installation, CUT PIPE." *Public 13: Touch in Contemporary Art* (Toronto: Public Access, 1996), pp. 65-83

Sarrazin, Stephen. "Channeled Silence (Quiet, Something 'is' Thinking)" *Gary Hill—I Believe It Is an Image* (Tokyo: Watari Museum of Contemporary Art, 1992).

Van Weelden, Willem. "Primarily Spoken." *Gary Hill,* in English with Dutch and German translations, (Amsterdam: Stedelijk Museum and Vienna: Kunsthalle, Wien, 1993), pp. 21-35.

Van Assche, Christine. "Interview with Gary Hill." *Galeries Magazine* (December 1990/January 1991), pp. 77, 140-141.

Young, Lisa Jaye. "Electronic Verses: Reading the Body vs. Touching the Text," *Performing Arts Journal 52* (Vol. 18, No. 1, January 1996), pp. 36-43

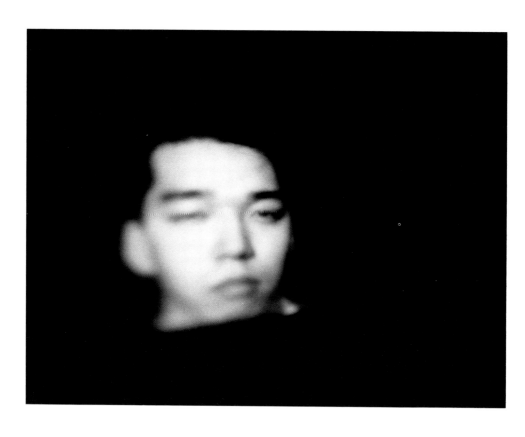

Beacon (Two Versions of the Imaginary) DETAIL (1990)

viewer, standing apart, & facing faces exhibitions

Kunsthalle, Vienna, Austria, group show: "Angel, Angel" including *Standing Apart* and *Facing Faces*, June 10 to September 7, 1997

Magneto, Centro Cultural Banco do Brasil, Rio de Janeiro, solo exhibition including *Tall Ships, Inasmuch As It Is Always Already Taking Place, Standing Apart* and *Facing Faces,* and *Clover,* July 2 to September 31, 1997 (Rio) and October 2 to November 2, 1997 (Sao Paulo)

Lyon Biennale, France, group show with *Viewer*, July 7 to September 24, 1997

SOLO EXHIBITIONS

1996-1997

Barbara Gladstone Gallery, New York, New York, November 17, 1996 to January 18, 1997

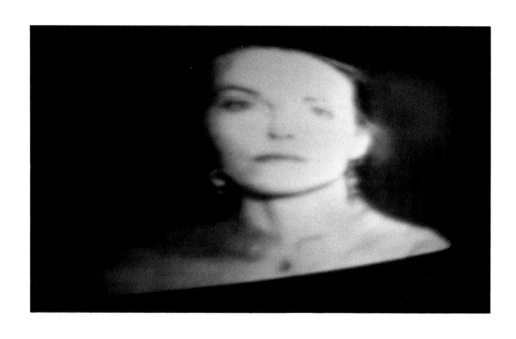

Beacon (Two Versions of the Imaginary) DETAIL (1990)

About the Authors

GEORGE QUASHA is the author of several published books of poetry including *Somapoetics, Giving the Lily Back Her Hands,* and the forthcoming *In No Time*; has edited several poetry anthologies including *America a Prophecy* and *Open Poetry*; and has been co-publisher/editor of Station Hill Press in Barrytown, New York since 1978. He is the recipient of a National Endowment for the Arts Fellowship in Poetry. He co-founded Open Studio, Ltd. and the Arnolfini Arts Center in Rhinebeck, New York in 1978. His ongoing collaborations with Gary Hill, begun in the late 1970s, include sound poetry performance (e.g., *Tale Enclosure,* a Gary Hill single-channel video), text and on-site direction for the installation *Disturbance (among the jars)* at the Centre Georges Pompidou in Paris, various kinds of writing and live performances, the latter extending his more than twenty years of performance and "dialogical" work with Charles Stein. George Quasha's work as artist (video, installation, performance) has been included in museum shows at The Center for Curatorial Studies in Annandale-on-Hudson, College Art Gallery at SUNY New Paltz, and the Blum Art Center in Annandale-on-Hudson, and, in a collaboration with Gary Hill and Charles Stein, at the Long Beach Museum of Art, California, The Museum of Modern Art, Oxford, England, etc. His collaborative writing related to Gary Hill's work has appeared in art catalogues of the Stedelijk Museum of Amsterdam, the Kunsthalle of Vienna, the Barbara Gladstone Gallery of New York, Public Access of Toronto, the Voyager Laserdisc Gary Hill, the Musée d'Art Moderne d'Ascq, etc. He has taught at SUNY Stony Brook, NYU, The New School for Social Research, Bard College, and The Naropa Institute.

～

CHARLES STEIN is the author of ten books of poetry, many of which include his photographs. The most recent book is *The Hat Rack Tree* (1994). He is also the author of a critical study (including his photos) of the poet Charles Olson, *The Secret of the Black Chrysanthemum*, as well as other essays on philosophical and literary subjects. He plays Gregory Bateson in Gary Hill's *Why Do Things Get in a Muddle?* and is one of the two performers (with George Quasha) in Gary Hill's *Tale Enclosure*. He has worked with George Quasha for many years in the production of "dialogical" critical texts. He holds a Ph.D. in literature and currently resides in Barrytown where he is Senior Editor at Station Hill Press. His photography has appeared in solo exhibitions at The College Art Gallery of SUNY New Paltz, The University of Connecticut Library in Storrs, The Arnolfini Arts Center in Rhinebeck, New York, the Robert Louis Stevenson School in New York, New York, and on the covers of numerous books of poetry and fiction. In collaboration with Gary Hill and George Quasha, he has performed at the Long Beach Museum of Art, California, The Museum of Modern Art, Oxford, England, The Rhinebeck Performing Arts Center, etc. His collaborative writing related to Gary Hill's work has appeared in art catalogues of the Stedelijk Museum of Amsterdam, the Kunsthalle of Vienna, the Barbara Gladstone Gallery of New York, Public Access of Toronto, the Voyager Laserdisc *Gary Hill*, etc. He has taught in Bard College's "Music Program Zero" and at SUNY Albany and The Naropa Institute.

Acknowledgements

Artist's acknowledgments:

For their assistance in realizing the works discussed here, the artist wishes to express his gratitude to Barbara Gladstone and the Barbara Gladstone Gallery (New York) and Donald Young and the Donald Young Gallery (Seattle). For additional exhibitions of specific pieces, thanks to Cathrin Pichler of the Kunsthalle (Vienna), Marcello Dantas and Lucy Needham Vianna of Magneto, Centro Cultural Banco do Brasil (Rio de Janeiro); Harold Szeeman, Thierry Prat, and Thierry Raspail of the Lyon Biennale.

For making the present publication possible, I wish to thank Barbara Gladstone and the Barbara Gladstone Gallery; George Quasha, Susan Quasha and Charles Stein of Station Hill Arts of Barrytown, Ltd.

Special hardware and software design by Dave Jones.
Production assistance Ian Stokes.
Further assistance Kelle Morrill.

Authors' acknowledgments:

The main works discussed in this volume— *Viewer, Standing Apart* and *Facing Faces*—were first exhibited at the Barbara Gladstone Gallery in New York in the fall of 1996, together with *Hand Heard*. The first and second of the four texts included here ("On View" and "Reflections in Passing") are adapted from a text composed to accompany the opening of that show. We thank Barbara Gladstone for commissioning our piece. The third text here, "*Standing Apart/Facing Faces,*" is adapted from one written for the catalogue of the group show "*Engel, Engel,*" curated by Cathrin Pichler at the Kunsthalle in Vienna (June 1997); we took the title of the exhibition ("Angel, Angel" in English) as a verbal and conceptual context for the material and metaphorical direction of our piece. We thank Cathrin Pichler for requesting the piece, for her special care with the German translation, and for printing the text in English. "Projection: The Space of Great Happening" was originally composed for the Gary Hill solo exhibition at Magneto, Centro Cultural Banco do Brasil, Rio de Janeiro, curated by Marcello Dantas. We wish to thank Marcello Dantas and Lucy Needham Vianna for commissioning the text, for their special care with the Portuguese translation, and for printing the text in English.

Incidence of Catastrophe (1987-88)